IMAGES
of America

SAN MARCOS

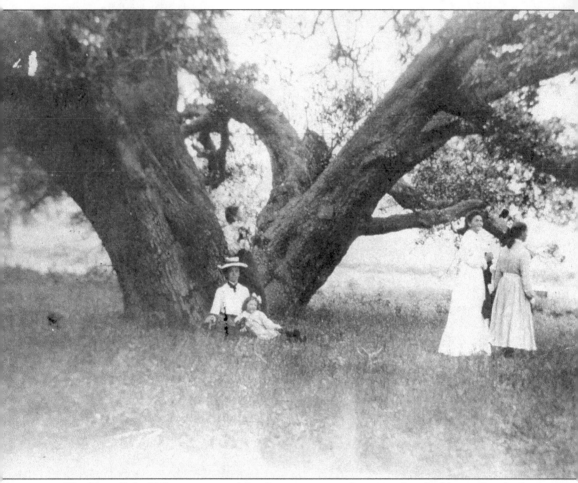

The Twin Oaks Valley was named for this enormous oak tree with a double trunk, which grew on the property of Major Gustavus French Merriam, one of the first homesteaders in the San Marcos area. In the 1980s, the rotting tree was damaged by lightning and was cut down. A new oak growth has now sprouted in its place. (Courtesy of San Marcos Historical Society.)

ON THE COVER: Early sustenance in San Marcos relied heavily on hay and grain farming, with hay baling and threshing crews a common sight. Crews were made up of local men and worked sunrise to sunset, six days a week. Seen here is the Huchting hay baling crew, with Henry Huchting standing at the far right. (Courtesy of San Marcos Historical Society.)

IMAGES
of America

SAN MARCOS

Charlie Musser and the San Marcos Historical Society

ARCADIA
PUBLISHING

Published by Arcadia Publishing
Charleston, South Carolina

Library of Congress Control Number: 2012951743

For all general information, please contact Arcadia Publishing:
Telephone 843-853-2070
Fax 843-853-0044
E-mail sales@arcadiapublishing.com
For customer service and orders:
Toll-Free 1-888-313-2665

Visit us on the Internet at www.arcadiapublishing.com

*To all those whose lives have vanished from history
like adobe bricks back into earth.*

CONTENTS

Acknowledgments 6

Introduction 7

1. Wee-la-me 9

2. Homesteading in the Little Valleys 13

3. Your Name Here, California 27

4. A Tour of the Early Neighborhood 37

5. From Sun Up to Sun Down 51

6. Silk, Milk, Chickens, and War 59

7. Making It Official 77

8. The Hub of Intellectuality 91

9. A Master Planned Community 111

10. The Valley of Discoveries 119

ACKNOWLEDGMENTS

This publication would not have been possible without the years of research, organization, and documentation done by previous members of the San Marcos Historical Society. Foremost is Ruth Lindenmeyer, who first organized the society's newspaper clippings and documents and conducted numerous interviews with local pioneer families, chronicling information that otherwise would have been lost with passing generations. Also, I thank William Carroll and Roy Haskins, whose past publications were invaluable references.

I owe immense thanks to current members of the society, who trusted me to produce the first book on San Marcos history in almost 40 years after only a few months of volunteering. Specifically, thanks to Tanis Brown for making me feel welcome since my first day, Mimi Kennedy for square dancing her way into my life, forever young Maryanne Cioe, and Jackie Hartley (I wish I could have had a meal under the mural at Hartley's Steak and Eggs).

Numerous families must be given thanks for photo donations including the Astleford, Bucher, Fulton, Huchting, Merriam, and Tobin families, although the list is so numerous, my apologies for not naming them all specifically here. The photographers known to have supplied images in this publication include Dan Rios, as well as Cenizom, Cosentino, Doyle, Drake, Edwards, Franklin, Kreisler, and Nilo, whose first names are unknown.

I must thank Mark Mojado, Cami Mojado, P.J. Stoneburner, and Paul Price who trusted me with sensitive information and made me feel like family since our first meeting. Further consultation and photographs came from numerous sources including Rachel Caldwell and the Golden Door Spa, Blake Isaac and Questhaven Retreat, San Marcos Brewery, the San Elijo Hills Visitor Center, and Alicia Yerman and the Vallecitos Water District.

Lastly, I must thank my family: my companion Rejoy Armamento for supporting me in innumerable ways; my Grandpa and Granny (who attended the 1910 schoolhouse) for supporting every crazy idea I conceive; my sister Malia, who keeps me in check; and my Mom, without whom I would never have had this opportunity.

Unless otherwise credited, all images come from the photograph collection of the San Marcos Historical Society.

INTRODUCTION

Many moons have passed since San Marcos was only inhabited by the Luiseño Indians, who lived a semi-nomadic lifestyle, moving periodically to areas between Palomar Mountain and the Pacific Ocean. Tribes would migrate in order to keep from depleting natural resources, and San Marcos was one of numerous areas where tribes set up semi-permanent villages, most likely during the colder seasons when Palomar Mountain was blanketed with snow.

Legend states that the first sighting of San Marcos, by persons other than indigenous inhabitants, was by a company of Spanish soldiers in pursuit of suspected Indian horse thieves. While the troops lost track of the suspected culprits, they happened to find themselves in a secluded landscape made up of small valleys. As the date was April 25, the feast day of St. Mark, the soldiers named the area Los Vallecitos de San Marcos, which translates to "the Little Valleys of Saint Mark." By 1798, Fr. Fermín Lasuén had established Mission San Luis Rey de Francia a few miles west, and the San Marcos area came under control of the Spanish government. Local Luiseño customs were deemed primitive, and a program of religious conversion, slavery, and assimilation was established by the Franciscan clergy. With the introduction of foreign diseases to which most tribes had no immunity, Spanish presence caused the native population to be cut in half within a quarter of a century, and a way of life practiced for multiple millennia was erased.

Following the Treaty of Córdoba in 1821, Mexico gained independence from Spain, ushering in the California *rancho* period. San Marcos was utilized mainly as open grazing land, inhabited only by the dwindling population of remaining Luiseños and ranch hands employed by the owners of Rancho Los Vallecitos de San Marcos, officially established as a Mexican land grant in 1840.

One unfortunate fact when dealing with history is that not all people or buildings leave a trace of their existence. An 1895 account of San Marcos states that "five old sea captains" lived in the area, but only the name of a Captain O' Brien is recorded. San Marcos was also definitely home to at least some Japanese immigrants, but following the attack on Pearl Harbor, the Japanese population was sent to relocation camps, and the local family names of Tannaka, Yammamto, Yasakocha, and others are left without a recorded story.

Architectural remains of any buildings once standing on rancho land have yet to be found, but accounts of multiple adobes scattered throughout the region exist as the only impression that any structures ever stood in San Marcos prior to 1875. Adobe houses are reported to have stood on the Frood Smith ranch and Merriam ranch, along with an adobe sheep grazing headquarters on the Bass ranch, formerly owned by John Hanson and the supposed site of long-lost buried treasure. Reports exist of early sheepherders driving flocks of hundreds of sheep down Mission Road, even up until the early 1900s.

San Marcos endures as an area steeped in myths and legends, which remain as the more lasting testimonies between multiple generations. The lost treasure at the Bass ranch was supposedly a horde of gold wrapped in a horsehair blanket, buried somewhere near the property by a sheep owner who was subsequently murdered by his employees. For years, the area was cratered with

holes dug by treasure seekers, including a speculator from Long Beach who arrived so convinced of finding the cache that he had even made arrangements with his bank to handle his newfound wealth. The only prize the gentleman found was a "tiny piece of metallic substance stuck on a giant boulder" underneath a haystack.

Other treasure seeking stories include a gold mine operated by two brothers following World War I in the northern portion of the Twin Oaks Valley and three strangers arriving on the Taite ranch with a map asking to dig, only to disappear by the next morning. Legends further claim that on certain nights, areas of the San Marcos valleys are said to glow like small fires and are believed to show where stolen treasures buried by Mexican bandits exist. Marcelino Couro, a local sheepshearer, documented that while traveling from Oceanside to San Pasqual, he passed through San Marcos and saw this "ethereal light." Couro claims that he hired two local laborers who, deep into the night, helped him dig in the spot where he had seen the light. Couro then went to sleep and upon waking found only a large hole and two empty rawhide bags.

The history of San Marcos, California is, at best, an incomplete collection of stories, legends, myths, recollections, and publications. One problem any historian must face is the disappearance of and subsequent retelling of historical events. History is not always an entity retained by generations in the form in which it originally took place or with every detail recorded accurately. More often than not, history is documented and retained by those in power, with some prior recollections altered or erased. Details that may have been considered unimportant or contrary to popular belief, or, most often, that exposed the negative aspects or actions of those in power, are often eliminated from the popular consciousness and rewritten with a contrived and positive perspective. Beings who have been conquered, displaced, "assimilated," or eliminated, and events surrounding their very existence, are given little recognition and may even be removed from surviving historical records. Politics, religion, language barriers, racial prejudice, and lack of written documentation, among numerous other factors, must be taken into account when judging and accepting any historical source and further constructing a complete and true historical account on any subject.

San Marcos has portions of its history that today have disappeared with passing generations and remain a mystery. Therefore, it must be admitted that this publication is an incomplete historical record of San Marcos. Not only does this book depend almost entirely on images, and mainly images captured by the invention of photography, but also voices, which do not exist for countless prior inhabitants who have not produced written records of family stories, newspaper articles, land deeds, or other documentation. In turn, this book is presented as a challenge for future historians to add and correct information that is missing or may, in time, prove to be incorrect. History is not idle and is meant to be interpreted and presented in diverse ways, with the ultimate purpose being to construct the truth of what has occurred before and has now become the world seen today. While progress and time have caused much of the past to be lost, historians must themselves be treasure seekers, pursuing the riches that remain to be discovered and preserved by future generations.

This book is meant to convey the presently known history of San Marcos through a collection of enduring images and is simply a building block for the future, so that one day history may represent all participants who construct the story of human kind.

One

WEE-LA-ME

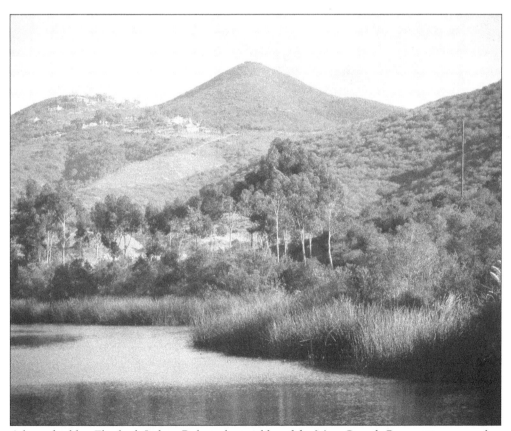

A legend told to Elizabeth Judson Roberts by an elder of the Mesa Grande Reservation states that in the beginning of time the All-Spirit Ah-mi-ya-ha created humans from clay and brought them west from the land of the rising sun. Under the care of the Wind-Spirit, they were placed on the tallest peak in San Marcos, Wee-la-me (also known as Mount Whitney), pictured here.

On Wee-la-me, the Wind-Spirit taught the people how they were to live, including their duties toward each other and the important songs of love, battle, and death. Everything was said to have a spirit—rocks, water, trees, and animals—and they could all communicate with one another. At first, all Indians were considered good, known as *quia-see-i*, and could speak freely with nature. After a time, the Wind-Spirit divided the people into tribes "and sent them to places on earth that were to be their homes," according to the legend related to Roberts. Pictured at left, at an undisclosed location, are some remnants of a Luiseño village, utilized during periodic migrations. The Luiseño inhabited a vast area stretching from Oceanside to Palomar Mountain and have left behind ancient traces of habitation, including the pottery fragment seen below.

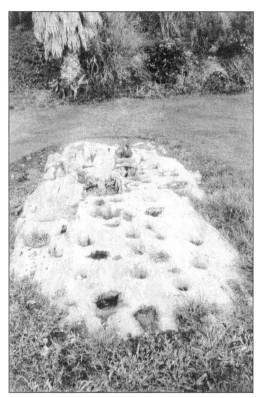

Many areas of Luiseño habitation include bedrock mortar holes, seen here on the Twin Oaks Golf Course. Located near the sixth hole, the site was dedicated as the Indian Kitchen in 2001. The rock outcroppings were used for grinding collected acorns and other food products with a stone pestle. Acorns were ground into a mush called *wiiwish* and were a main dietary staple, but seeds, roots, berries, and wild game were also consumed. Elderberries, which grew wild near natural water sources, were often found near village sites. Circular hollows referred to as cupules, as seen in the second image, have also been found at various archaeological sites and are believed to have been formed by chipping or grinding and were used for ceremonial purposes. Cupules can be mistaken for smaller-scale mortar holes but are believed to be associated with art, not sustenance.

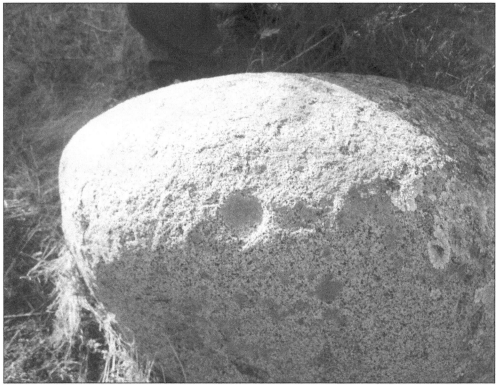

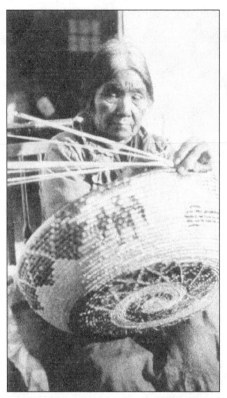

A demonstration of basket making is seen here, displaying one of several forms of coiled baskets utilized by the Luiseño in varying ways. The flat basket, called *tukmal*, was used for winnowing seeds, a process in which particles were lifted in the air allowing the wind to remove excess particles before falling back into the basket.

Pictured here is an example of petroglyphs left by early inhabitants. Petroglyphs, pecked into rock, and painted pictographs were art forms practiced by the local Luiseños, often by shamans or for girls' puberty ceremonies. Efforts by the local San Luis Rey Luiseño Band of Mission Indians to protect sacred sites continue, although to this day the tribe remains federally unrecognized despite evidence of regional habitation.

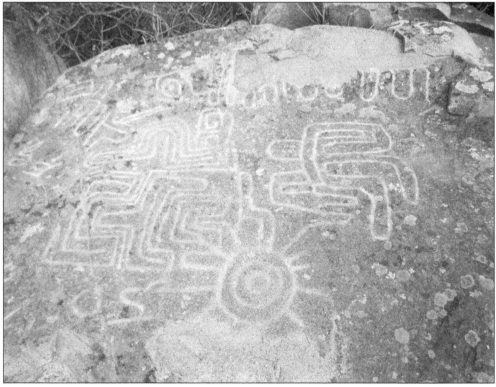

Two

HOMESTEADING IN THE LITTLE VALLEYS

Beginning with the founding of Mission San Luis Rey de Francia in 1798, the area of today's San Marcos was most likely utilized as herding ground for the enormous herds of cattle and sheep that Spanish missionaries and their laborers managed. Nearly two decades following Mexican independence from Spain, in 1840 Don Jose Maria Alvarado was granted 8,877.49 acres as Rancho Los Vallecitos de San Marcos by the governor of Mexico. Pictured here is the brand utilized by the rancho.

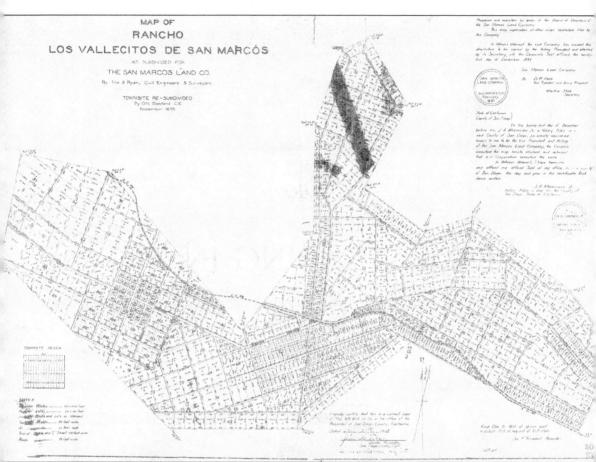

Jose Maria Alvarado was killed near Rancho Pauma in 1846 along with 10 other Californios who had stolen a herd of horses belonging to a Pauma band of Luiseño Indians just after the Battle of San Pasqual. The supposed instigator of the killings, William Marshall, who was captured and sentenced to hang, had been a suitor of Alvarado's wife, Lugarda Osuna, who accompanied Marshall to the gallows. After the end of the Mexican-American War, Lorenzo Soto filed a claim for the rancho with the United States Land Commission in 1851, possibly taking advantage of the confusion surrounding the ownership of Mexican land grants, now a part of United States territory. After Soto's death, his widow, Maria Ygnacia Morena, married Tomas Alvarado, part owner of Rancho Monserate. Alvarado sold the San Marcos land and livestock to Cave Johnson Couts, sub-agent for the San Luis Rey Luiseño Band of Mission Indians in 1866.

14

Cave Johnson Couts was a West Point graduate and former slaveholder in Tennessee before marrying Ysidora Bandini. They would live at Rancho Guajome, which was a wedding present from Ysidora's brother-in-law Abel Stearns. Couts would acquire vast amounts of property and political influence and live like a monarch, complete with two sprawling adobes, Luiseño indentured servants, and 20,000 acres of land including the San Marcos rancho utilized for grazing livestock.

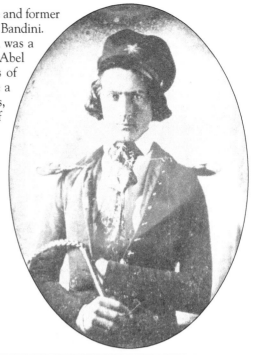

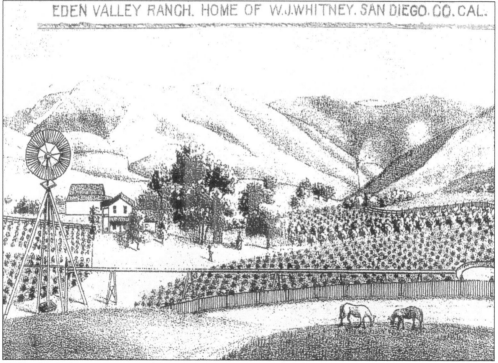

EDEN VALLEY RANCH. HOME OF W.J.WHITNEY. SAN DIEGO. CO. CAL.

Willard J. Whitney was a colorful viticulturist who often wrote letters to the editor of the *San Diego Union* giving advice on grape growing and wine making. Whitney homesteaded a ranch near present Harmony Grove from 1869 to 1886. By 1889, Public Land Survey maps honored Whitney by naming San Marcos's tallest peak Whitney's Peak (later Mount Whitney).

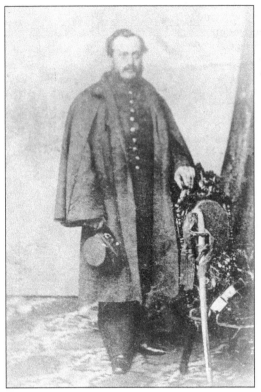

Born a relative to creators of the *Merriam-Webster Dictionary*, Gustavus French Merriam gained entrance into the US Naval Academy at Annapolis in 1854 and was eventually promoted to major during the Civil War. After marrying Mary Elizabeth "Nina" Scott and settling in Topeka, Kansas, for a time, the major moved his family to the Twin Oaks Valley in search of a mild climate to help improve his wife's ailing health in 1875.

The original Merriam homestead was built with materials hauled from San Diego along the Poway grade, a tough trip made over the course of multiple days. The Merriam family had accumulated small amounts of materials themselves and, using ox-drawn carts with solid wood wheels borrowed from the Bandini family, began to set up a home upon arrival. The major is seated in the background on the right.

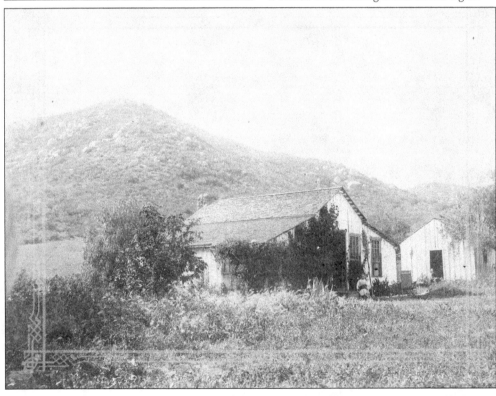

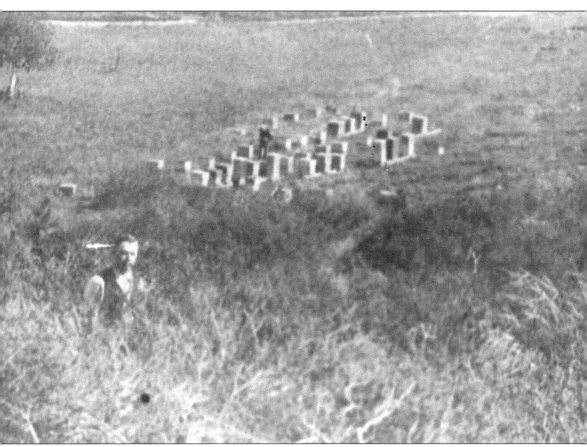

Within four days of settlement, the Merriam family was accosted by four rifle-touting *vaqueros* asserting that the family was on property owned by the rancho and that they had 24 hours to "get out of the country." Gustavus Merriam, who had previous surveying experience, replied that he knew where the property lines were and that the homestead was situated north of rancho land. The family would stay put but not without continuous harassment by the vaqueros, who at night would drive horses onto the fields of crops the family had planted, devastating crop yields. In response, the family would turn to raising honeybees as a cash crop. Honey would be shipped to San Francisco and then to Australia in 25-gallon pine barrels. Here, Edwin Merriam, son of Gustavus, is seen near the family apiary. Another economic success for the Merriams was the production of wine and brandy, made from grapes grown in their vineyards. Grape brandy was sold at $2.50 a gallon, with port, angelica, and sweet muscatel wine selling for 75¢ a gallon.

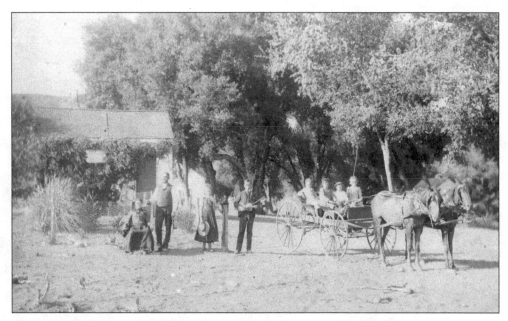

In 1885, a group of German families from Chicago arrived at the Olivenhain Colony, in present day Encinitas, expecting fertile farmland and an abundance of water as advertised by the Kimball Group, deceitful realtors from National City. "We found only two olive trees and bare hills of sagebrush. We were victims of one of the early California land swindles," recalled Elizabeth Oden (seated at left). The Odens, along with the family of Jacob Uhland (standing below) renounced the Olivenhain Colony and moved together to an adobe barn just south of Meadowlark Ranch. For a number of weeks, in need of work, fathers George Oden and Jacob Uhland walked eight miles to the Merriam ranch on Sundays, returning home on Saturday evening to take a bath.

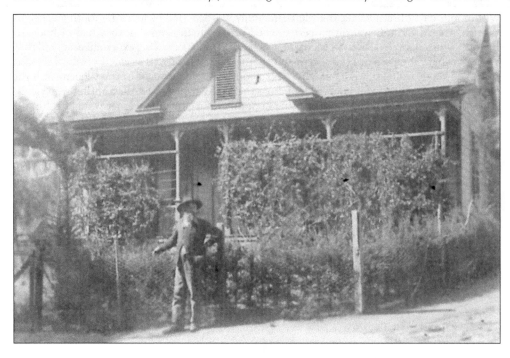

Major Merriam soon assisted George Oden and Jacob Uhland in filing for homesteads in the Twin Oaks Valley. Oden acquired 160 acres west of the Merriams for $200 from a previous homesteader, who had only managed to build a shack, while Uhland settled just east and built a home, pictured here, along present Deer Springs Road, named "Uhland Canyon" by early pioneers.

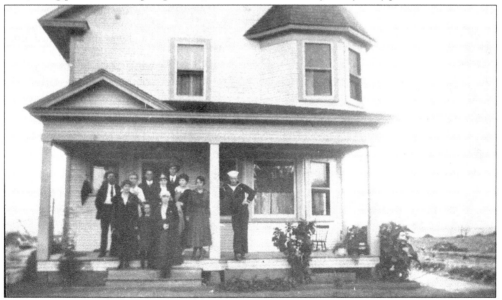

Although not part of the Olivenhain Colony, John and Mary Harrison had also come from the Midwest to California, hoping to improve John's health. By 1885, they filed for a homestead in Twin Oaks Valley and lived in a bee house where their son Hiram was born before completion of their home, pictured here in 1920.

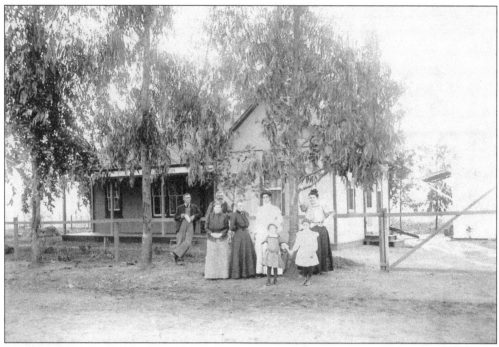

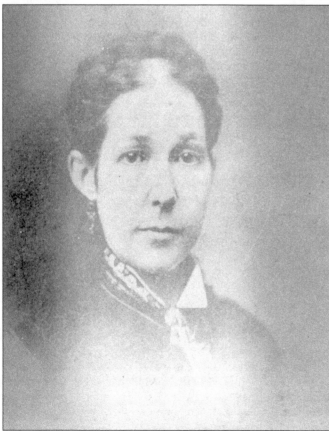

Peter Cochems (second from left, with beard), a cigar maker, and Michael Mahr, a cabinetmaker, also left the Olivenhain Colony. With a tip from fellow German Jacob Uhland, Cochems homesteaded just north of the Merriams, while Mahr homesteaded south at the base of the Mount Whitney foothills.

By 1887, the Twin Oaks Valley had developed into a community of many families. Mrs. Oden was the caretaker of Major Merriam's wife Nina, shown here, who was sick with tuberculosis and would be dead by 1888. Mrs. Cochems acted as the community midwife and cared for Mrs. Harrison after the death of her newborn.

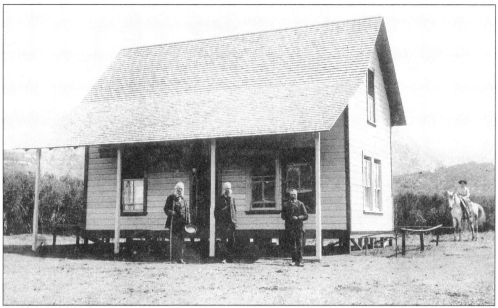

In 1889, Major Merriam was visited by his brothers Clinton and William Wallace Merriam. Clinton was a New York congressman, who had visited his friend John Muir en route to the Merriam homestead. Impressed with the Twin Oaks Valley, Clinton commissioned his brother to build La Mesita, the house pictured above, which would be his vacation home. Clinton also brought his daughter Florence Merriam, who in both pictures is riding sidesaddle on her horse. Florence was a naturalist and writer and after visiting in 1889 and 1894, published *A-Birding-On-A-Bronco* about her experiences with the natural surroundings and people around the Merriam homestead. Below, the Merriam family is gathered under the Twin Oaks Trees, located near the Merriam home, after which Major Merriam named the Twin Oaks Valley.

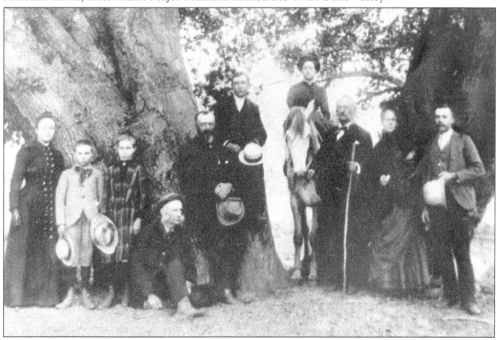

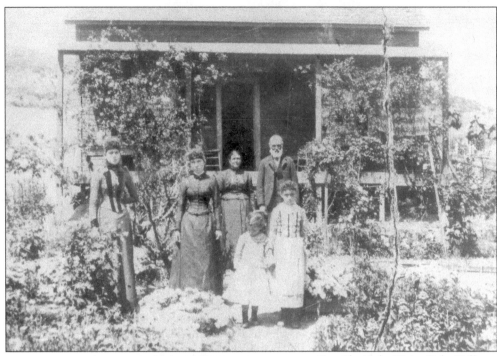

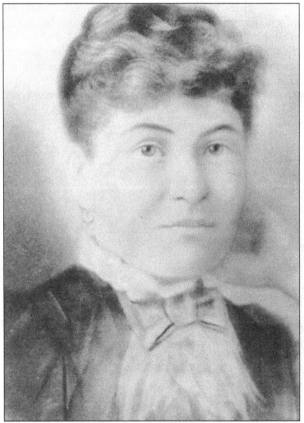

Outside of the Twin Oaks Valley, in 1879, Jose "William Joseph" Wilson (standing at right in back) moved from Ventura County to Meadowlark Ranch with his daughters Josefa and Rosa (left and second from left) and wife Refugio Gonzales (second from right in back). The Wilsons' ranch straddled the rancho to the south, and they subsisted alongside the families of Juan Ortega, vaquero on the rancho; Alexander Carpenter; and William B. Couts, brother of Cave Johnson Couts.

Tomasa Gonzales Peralta Tico, the daughter of Refugio Gonzales Wilson and her first, deceased husband Pablo Gonzales, also settled with the Wilson family. Tomasa originally married Victorino Peralta, who died in 1887, and then married Juan Tico, who homesteaded just south of present Questhaven Road, then called the Fresno Valley.

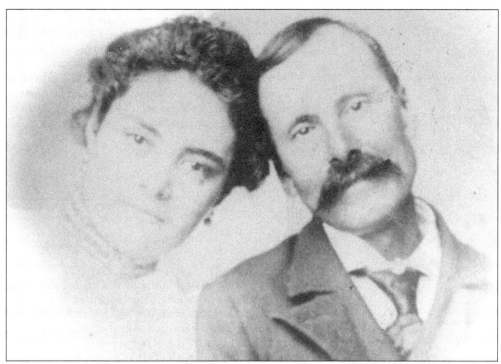

Salvador Gonzales, brother to Tomasa Gonzales Peralta Tico, is pictured above with his niece, Tomasa's daughter, Beatrice Peralta. Salvador Gonzales acquired land adjacent to the Meadowlark Ranch that would become the Meadowlark Cemetery. The cemetery is now located within the center divide near the intersection of Rancho Santa Fe Road and Meadowlark Drive. Entombed there are Tomasa Tico, who died of tuberculosis; her son Alfredo; her sister's father-in-law Casildo Figueroa; his grandson Jose; local rancher Felipe Sanchez; and ranch hands Jose Urbano and Ramon Morales. Morales was shot by Parker Dear Jr., grandson of Cave Johnson Couts, after an argument over wine. While Dear was acquitted, judged acting in self-defense, Morales's mother begged the family to allow her son to be buried on their land.

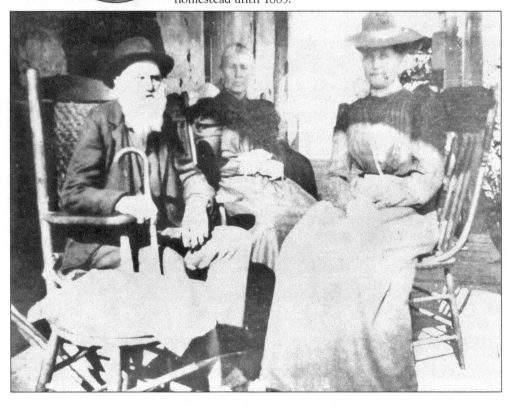

En route from Germany while attempting to hop ship to Hawaii, August Huchting (seen here), became so impressed with Ventura County's lima bean production, he stayed put and married Marie Conception Gonzales, daughter of Refugio Gonzales. They moved to the Richland Valley in 1882 and lived in an old ranch house located within rancho boundaries before moving to Meadowlark Ranch to be near the Wilson and Gonzales family.

James Frances Barham, seated with his wife Jane and daughter Sarah Barham Carpenter, at one time owned 100 acres in Santa Ana, which grandson Thomas Barham explained was acquired by the Santa Fe Railroad after railroad agents "got grandpa pretty tipsy," forcing the family to move south. The Barhams were listed in the 1880 census of San Marcos but did not officially file a homestead until 1883.

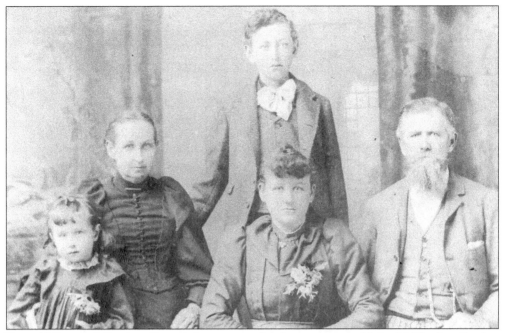

Reynold Bascomb Borden (far right), a native of Arkansas, married Julia McKendree Borden (second from left) in 1873 and then set out on a cross-country wagon trek to Downey, California. In 1882, they brought their three children Dora, Lea, and John (standing) to the Richland Valley, where they homesteaded 335 acres east of the rancho.

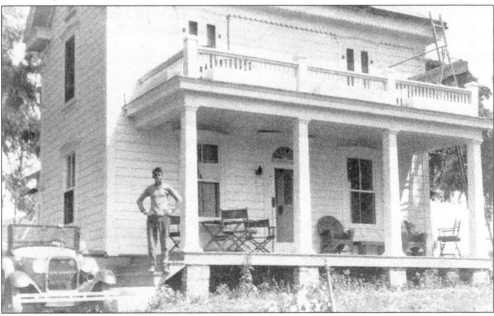

The Bordens raised bees and grew grain in the field where Richland Elementary would later stand. They built a two-story southern-style mansion, completed in 1884, using thin, overlapping, horizontal wooden boards for the walls. This photograph of the house around 1940 shows the columns and deck added by later owner Margaret Jorgenson, who also installed what became the first indoor bathroom in San Marcos.

William Justice, a Texan, also came to the Richland Valley en route from Downey, California, in 1882. Justice was married to Margaret Ann Merchant and had 10 children. This photograph is believed to show Justice's granddaughters Maud and Viola, born in the Richland Valley. Justice was a preacher and gave the area the name Richland for being a land rich with beauty.

Other names associated with the San Marcos area include John W. Isbell, a road builder; Juan and Marie Itzaina, Basque sheepherders; and Charles Wing Johnston, a retired army veteran who had stood guard over condemned Sioux warriors following an uprising in Minnesota. Johnston lived in the Johnston-Hannegan house near Rock Springs Road, shown here, prior to his death.

Three

YOUR NAME HERE, CALIFORNIA

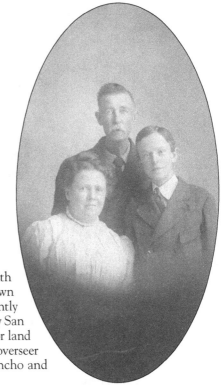

Beginning in 1883, James Frances Barham, along with his son John Henry Barham (center), laid out the town of Barham on the northwest corner of C Street, presently Rancho Santa Fe Road, and Encinitas Road, presently San Marcos Boulevard. The Couts estate sued Barham for land infringement, but by January 1884, the office of the overseer declared the land outside the boundaries of the rancho and free for homesteading.

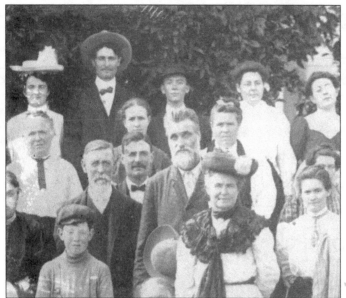

William Webster Borden (center, with beard) became the most prominent citizen of Barham. While serving as the town's postmaster, schoolteacher, and preacher, every Saturday Borden would release the first local newspaper, *Our Paper*, which later became *The Plain Truth*. The paper featured local happenings, political opinions, and self-promotion for "Shabby-town," as the town was often referred to, and was "devoted to the promotion of intelligence and virtue."

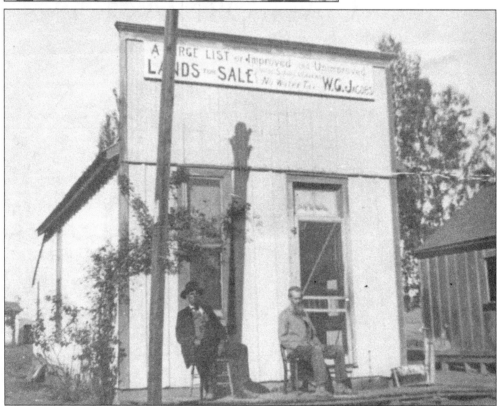

By 1887, a lengthy lawsuit concerning inheritance of the rancho following the death of Cave Johnson Couts was decided, and Ysidora Bandini Couts was able to dispose of the property. The rancho initially sold to New Yorker O.S. Hubbell for $225,000, who one month later sold it for $233,000 to a real estate group recently incorporated as the San Marcos Land Company, whose local office is pictured here.

Taking care of local affairs for the San Marcos Land Company was Worden Grove Jacobs, the loquacious resident land agent and animal lover. Jacobs later resigned and moved to Humboldt County, where he was blinded in an industrial accident. He returned to San Marcos where he lived out his days, riding his horse Duke that was trained by Jacobs's voice to know where to take him.

The original San Marcos town site was located at the intersection of C Street, now Rancho Santa Fe Road, and Grand Avenue. The buildings pictured are, from left to right, the W.G. Jacobs Real Estate building, the Gailey residence, the Cottage Café, and A.H. Gall's San Marcos Store and post office. The town also featured a 26-room hotel, run by Richard Witty, and free water for the use of citizens.

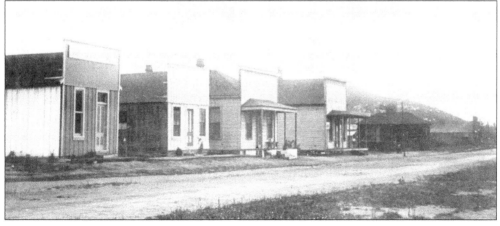

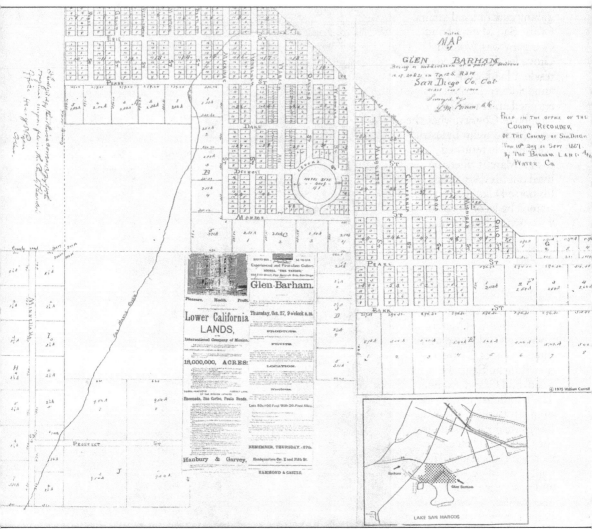

At its peak, Barham consisted of a general store, a steam flouring mill, and a whiskey mill (all owned by the Barham family), a blacksmith shop, livery stable, post office, and the first school in the area, which also served as the church where William Webster Borden taught after passing a "teachers test" allowing him to teach anywhere in the state of California. Struggles persisted for Barham residents, as wheat, which residents depended on to bring economic success and sustainable crops, failed. A new land development called Glen Barham, a speculative subdivision, complete with a map, visible here, was touted as having sufficient water "to supply a city of 30,000 people" but failed at finding investors and settlers in competition with San Marcos just a few miles away. By 1889, Borden changed his paper's address to San Marcos, the post office was moved to the "thriving" town, and Barham, California, faded into obscurity.

BUY..

A Cheap

and

Pleasant

[SANTA FE DEPOT, SAN MARCOS, CAL.]

◆——IN THE——◆

HOME San Marcos Valley.

◆

30 Miles North of San Diego.

◆

8 to 10 Miles from the Ocean.

◆

ELEVATION 600 FT.

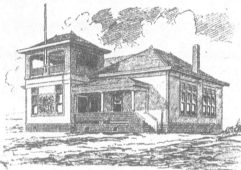

[PUBLIC SCHOOL, SAN MARCOS, CAL.]

UNEXCELLED for health. No extremes of heat or cold; no sand storms nor cyclones, but a gentle sea breeze the year round.

Soil first-class; water near surface; no irrigation tax. Most of this land is under cultivation, producing large crops of fruit, grapes, grain, hay and vegetables. Good society, churches, schools, hotel. No saloons allowed.

PRICES—$15 to $35 per acre, in tracts to suit. Improved ranches from $60 to $125 per acre. Free carriage to show property. For information address:

W. G. JACOBS,

San Marcos, San Diego Co., Calif.

☞ Please Tack this up in a Conspicuous Place.

The first survey for the Southern California Railroad had been routed through the original town of San Marcos, prompting residents to build a train depot. To the dismay of townsfolk, when construction on the railroad began, the tracks were laid nearly two and a half miles away at Mission Road and Las Posas Road. For years, the town attempted to draw investors with cheap rates, $15 to $35 an acre, and "no saloons," as seen in the bulletin. While the "gentle sea breeze" was pleasant, the town was floundering due to its distance from the railroad. In 1901, residents dragged the four main town buildings by teams of mules to present Mission Road and Pico Avenue to be adjacent to the train tracks. By 1906, the train depot was moved by steam engine and placed just across the street, south of town.

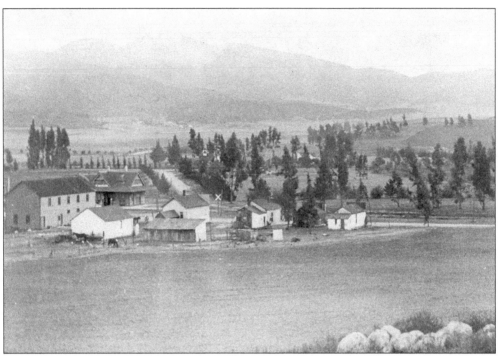

By 1908, the town of San Marcos was set in its location, where it would remain for good. This view is looking south along Mission Road, which cuts across the photograph with Pico Avenue on the left. In the background is the Mahr homestead at the base of Mount Whitney.

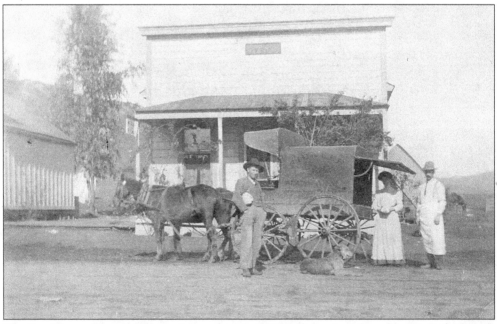

The San Marcos Rooming House is seen here in 1905, offering "meals and rooms," which took the place of the neglected hotel left back in the "old town." The wagon is owned by a traveling salesman, selling frozen meat to supply the boarding house with adequate food for many guests.

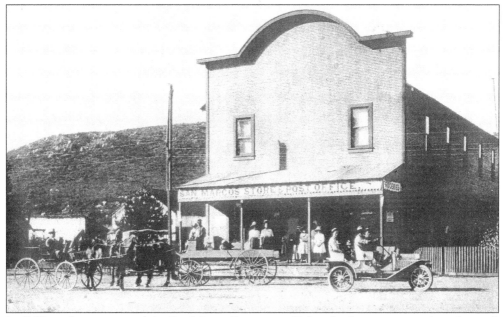

In 1907, residents organized the San Marcos Promotion Club, a fundraising group whose first task was to raise money to build the new, two-story San Marcos Store and post office. This photograph may have been taken near opening day, as the lettering is still displayed in cloth and customers are dressed in their Sunday best.

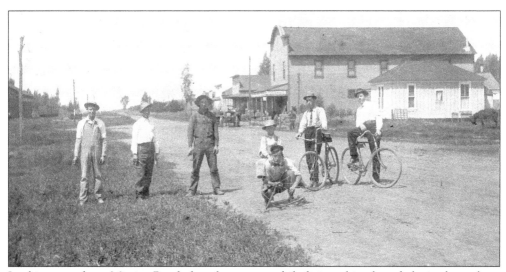

Looking west down Mission Road, these boys pause while fixing a bicycle and playing horseshoes to pose for a local photographer. On the left is an idle boxcar, located near a warehouse owned by the Escondido Feed and Grain Company, along with a pole used for telephone lines. Bicycle helmets and jaywalking laws had not yet been invented.

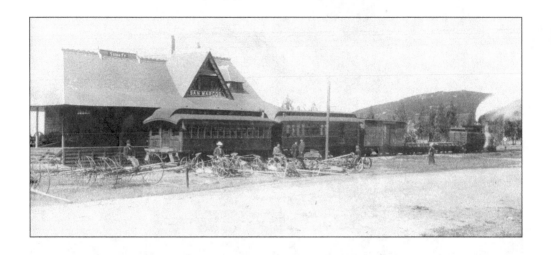

The Santa Fe Railroad would run passenger and freight trains between Oceanside and Escondido until 1946. An important link for the community of San Marcos, trains also transferred the means of economic survival for the community, including export of poultry, grains, hay, and fruit. By 1912, four trains a day stopped at the San Marcos depot. Below, passengers await a train, which will transport the cans of milk loaded on the wagons at right. A telegraph office was also an integral aspect to the depot. The depot master, seen on the far left holding papers, acted as the telegraph operator.

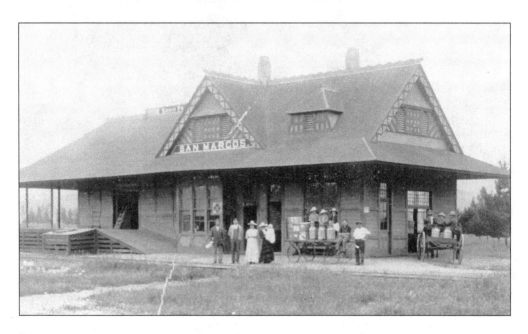

From the 1890s until the 1920s, Richland, California, pictured in 1890 near Richland Road, was considered a separate, blossoming town—related to but separate from San Marcos. The Richland School, seen above on the hill to the left, was used as a meetinghouse and church. In 1894, J.N. Tuck built a store on the south side of the railroad tracks that ran across Richland Road in which he established a post office where the railroad stopped for "mail and passengers." Tuck acted as postmaster until 1907, when the railroad built the Richland Railroad Depot across the street. For over 20 years, Richland, California, enjoyed daily trains, as seen below, until the station was closed in the 1920s and Richland was more or less absorbed by San Marcos.

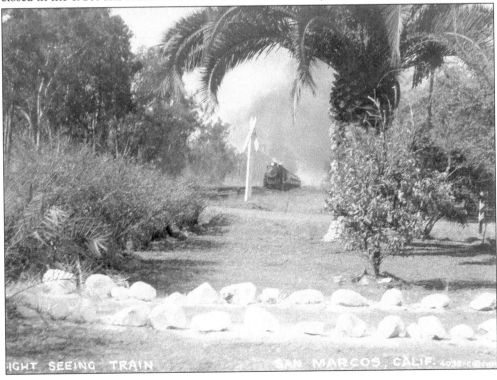

SIGHT SEEING TRAIN SAN MARCOS, CALIF. 4938-C

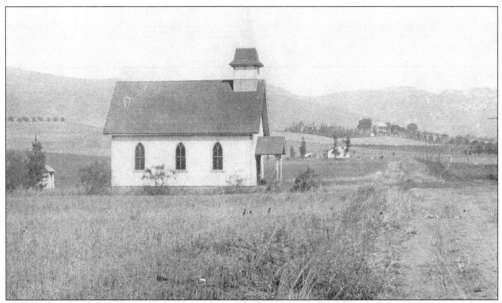

By 1895, residents of Richland had formed a Methodist congregation and built the Richland Methodist Episcopal Church, pictured above in 1900 near Richland Road and Mission Road. In 1902, residents of San Marcos acquired the former Encinitas Methodist Church, hauling it in four sections to the corner of San Marcos Boulevard and Pico Avenue. Arrangements were then made for the congregations to converge, and for the Richland church to be sawed in half and placed on both sides of the new church as wings. When the San Marcos Methodist Episcopal Church, pictured below in 1910, was completed, only the steeple was missing from the original Richland Church. The church now stands on Rose Ranch Road and is known as Grace Episcopal Church of the Valley.

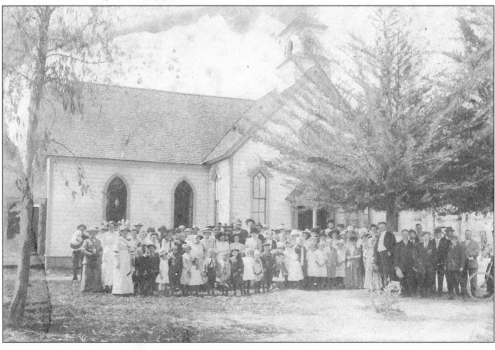

Four

A TOUR OF THE EARLY NEIGHBORHOOD

Looking down San Marcos Boulevard in 1908 presented quite a different view from today. Carl Huchting remembered that "blackberries grew thickly down at the creek in back" of this house, likely inhabited by "Grandpa" Van Dorin at the time. Eucalyptus trees are seen lining the road, as "civic beautification" was in full swing. Numerous trees were planted along the main thoroughfares connecting San Marcos to Escondido.

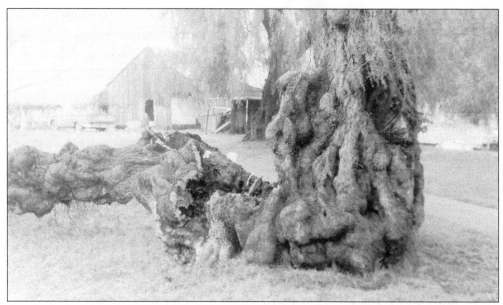

Another transplant to Richland from Downey, California, named John Wilson Fulton settled the Fulton Ranch homestead with his wife, Ida, in 1893. The ranch house was perched atop the hill on Fulton Road with an enormous pepper tree in the yard out front. The family harvested oat and hay on land that is now mostly Madrid Manor Mobile Home Park, although the house still stands.

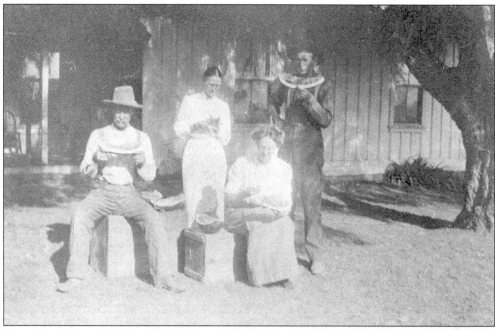

From left to right, John, Ida, "Bluebell," and Albert Fulton enjoy watermelon on the Fulton Ranch. Anna Eloise Fulton received the name Bluebell due to her eyes being "as blue as bluebells." She became a teacher at the Old Richland School in 1915 but was reprimanded by the principal who said, "Bluebell is not a dignified name for a school teacher."

Francisco Lusardi, second from left, came from Italy to California in 1866 and homesteaded near present day Rancho Bernardo in an area known as the Lusardi District where he would marry and raise a family. In 1896, Lusardi traded his interest in the district for 160 acres in Aliso Canyon, today known as Elfin Forest.

Andrew Nicholas and Anna Marie Nordahl arrived with their family in the Richland Valley in 1893 and lived in this house on Nordahl Road. A family of Swedish immigrants, the Nordahls would prosper from grain farming. Andrew Nicholas was also considered one of the first local preachers and held Sunday church services in Swedish in the Richland Schoolhouse.

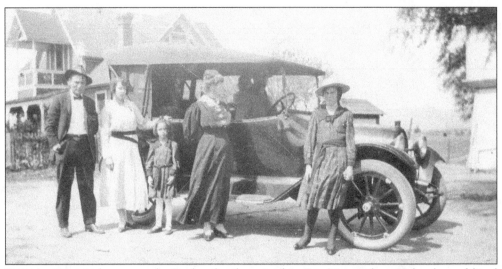

Swiss immigrants known as the Bucher family arrived in San Marcos from Nebraska and lived near the Nordahls. The Nordahl and Bucher families were joined with the marriage of Andrew Nicholas Nordahl's son Andrew William to Alice Bucher. Pictured in 1918 from left to right, Joseph "Ed" Bucher, Gertie Bucher, Ida Nordahl, Alice Bucher Nordahl, and Ella Nordahl stand in front of the Nordahl residence before a Sunday church service.

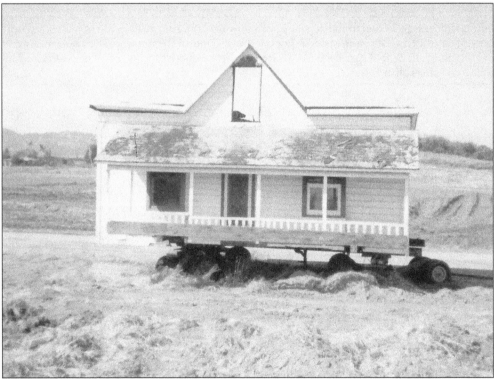

Built by Joseph "Ed" Bucher in 1895, the Bucher-Grangetto House once stood off Nordahl Road on the Buchers' 20-acre farmland. Later bought by the Grangetto family, the house was moved to 961 Richland Road in 1983, where it stands today. This photograph shows where the house stood just prior to being moved.

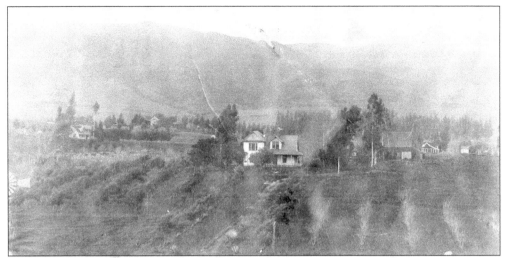

The Hartshorn family traveled from Illinois to settle in the Richland Valley in 1890 and left a lasting architectural impression upon San Marcos. The Hartshorn and Wood residence, shown here around 1895, was the first family home and was built by Horace Hartshorn upon arrival, with the Golden residence to the right. In 2001, a time capsule was unearthed to the right of the two-story house, which still stands as part of Woodland Park.

Horace Hartshorn also built the Blake-Short House in 1893, located off Rock Springs Road near the family residence seen here on the distant hill dusted by snow in 1949. The Hartshorn family would only remain in Richland until 1905; by 1907, Charles Hartshorn was the acting marshal of El Centro, California.

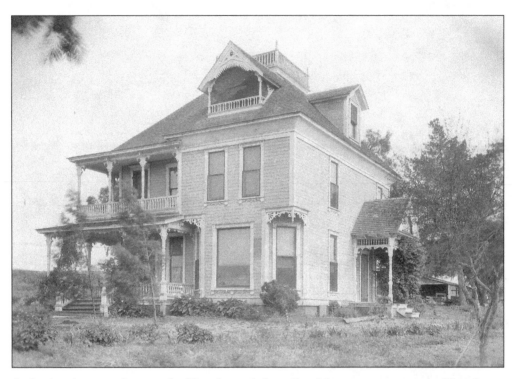

A third architectural stamp the Hartshorns left on San Marcos remains as the Hartshorn-Solomon-Olmsted House, pictured above in 1926 at its original location on Rock Springs Road, which was the main wagon road between San Marcos and Escondido. Built in 1893 by a local builder named McDonald for Horace Hartshorn's father, the Palmway Ranch featured a long row of palm trees leading up the driveway, seen below with a small boy playing on the carriage step. The house was often the scene of social occasions, including the welcoming reception for the new minister of the First Baptist Church of Escondido in 1905. Bought by the Solomon family in 1926 for $600 and sold to the Olmsted family in 1976, it was moved several times before finding a permanent location at 1142 Calle Maria.

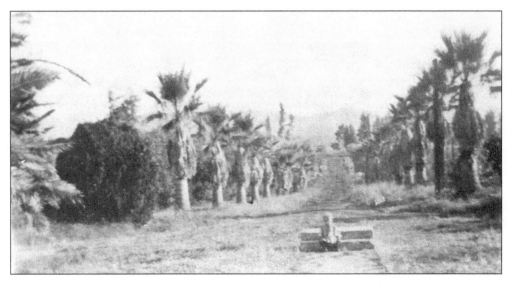

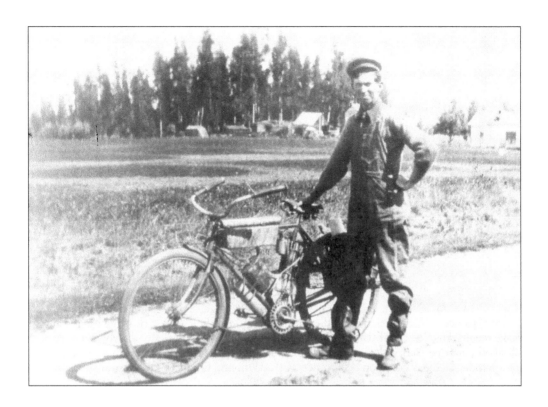

John Arthur "Art" Gailey was one of the most prominent residents of early San Marcos, with his residence one of the original four buildings moved to Mission Road. Gailey carried the rural mail for 30 years, first on horseback, then by motorcycle (pictured above), and finally by car. He had the first automobile in San Marcos and would often have Henry Huchting and his fox terrier ride on the radiator for assistance. During rain, a large umbrella covered the car, and Huchting carried a long pole to test if submerged bridges were still holding. During the Flood of 1916, a bridge collapsed during crossing, and the car was pulled out by a team of mules. It would be the only time Gailey, pictured with his family below, did not complete his mail route.

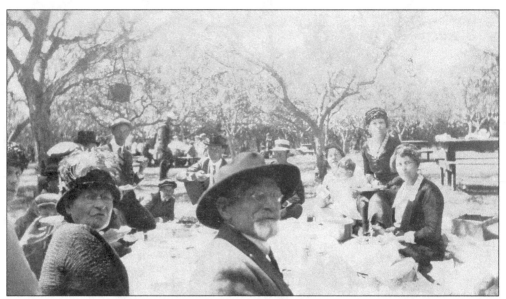

In 1893, pioneer George Oden was killed after falling into the family well while attempting to make repairs. His wife Elizabeth remarried Alvin Frohburg in 1896, and his daughter, also named Elizabeth, married Henry Huchting in 1901. The Oden and Huchting families are gathered here for a Sunday picnic, a common occurrence, with Alvin and Elizabeth Frohburg at the front.

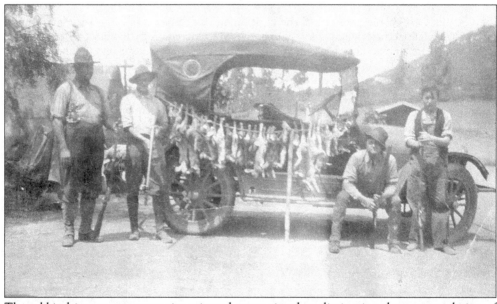

The rabbit drive was a community-oriented event aimed at eliminating the overpopulation of rabbits, which could destroy crops, and at stockpiling meat and pelts. Seen here parked near Vineyard Road, local blacksmith Fred Oden (second from right) and his associates display the day's catch along with their rifles. Wild game, which fed the early community, included rabbit, dove, quail, and deer at times.

44

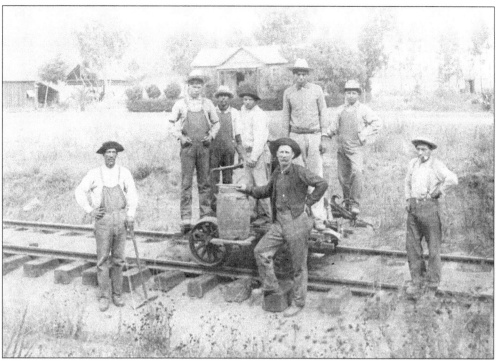

Pictured above is the section crew for the portion of the Santa Fe Railroad running between Vista and Escondido. At left is Jose Nunez and at front center is Milo Denny, the section foreman. Denny, his wife Alpha, and daughter Vina lived just north of the San Marcos Market in the railroad section house, seen below. Beginning in 1910, Denny let students returning home from Escondido High School ride his train, dropping them off at their respective stops along the route. Denny was normally off work by 5:00 p.m. but was on constant call during the Flood of 1916 as the tracks went out regularly.

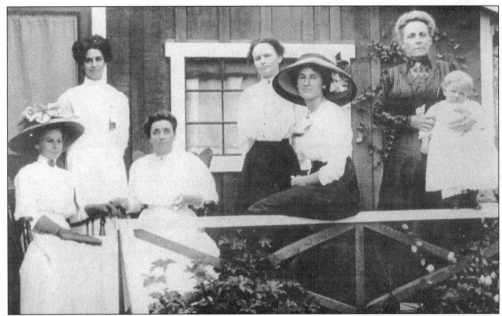

Shortly after having a self-proclaimed nervous breakdown, Edward Cochems, son of Peter Cochems, taught himself photography and published an article "How I Won My Way Back to Health with Photography." From 1912 to 1917, Cochems ran a photography studio on Mission Road. Posed in front of the studio are, from left to right, ? Itzaina, Emma Cochems, unidentified, Elizabeth Huchting, Emily Itzaina Astleford, and Anna Cochems holding Adelaine Cochems.

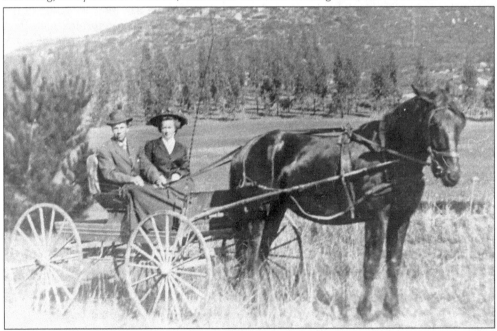

Pictured in 1913, John Hanson and his sister Hilma Hanson Mahr are seen taking a carriage ride through the Twin Oaks Valley. In a prime example of how San Marcos pioneer families intermarried, John Hanson married Ida Nordahl, daughter of Andrew Nicholas Nordahl, and Hilma Hanson married Louis Mahr, son of Michael Mahr.

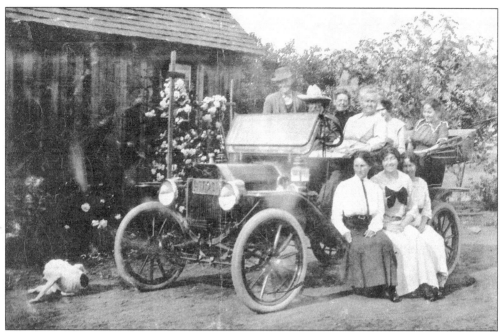

Anson Astleford and his wife Josephine Barnes came from Nebraska in 1892 and spent their first night locally at the San Marcos Hotel in "old town" San Marcos. Pictured here at the Astleford home in the Twin Oaks Valley are, from left to right (running board) Emily Itzaina Astleford, ? Kelly, and Myrtle Astleford; (front seat) Leland Astleford, Anson Astleford, and Josephine Barnes; (back seat) Josephine's sister "Barney" Barnes, Ilda Astleford, and Elsie Astleford.

The Cox family, pictured here, were originally dairy farmers in Aliso Canyon, near San Elijo Hills, before moving to the Twin Oaks Valley in 1923. The family lived on Cox Road, which runs between Mulberry Road and Sycamore Road, in a house built by Jacob Uhland in 1888. The family sold and delivered milk in bottles and had one of the first successful dairies in the area.

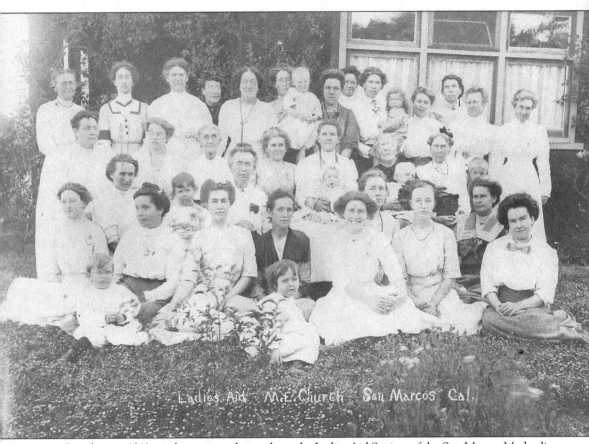

Ladies Aid M.E. Church San Marcos Cal.

Seen here in 1911 are the women who made up the Ladies Aid Society of the San Marcos Methodist Episcopal Church. The Ladies Aid was an organization devoted to "the spiritual, social, and financial welfare of the church." The society's main purpose was for church fundraising through themed dinners. A Guessing Supper required guests to select their food through coded burlesque names including "A Silenced Squealer" (pork), "Sad Predicaments" (pickles), and "Pressed Cow-Juice" (cheese). For the Mum Supper, regular admittance was charged, but "an additional charge is made every time a person seated at the table makes any remark." These, and other various party ideas designed to result in "much merriment" can be found in the 1911 official *Ladies' Aid Manual* by R.E. Smith.

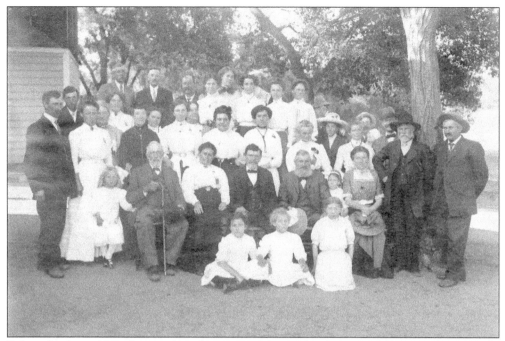

Believed to be in 1910, this may have been one of the final gatherings of the original Twin Oaks Valley pioneers. Seated at left is Major Merriam, who would die after being struck by a trolley after moving to Los Angeles in 1914. Seated fourth from left is Peter Cochems, who would die of cancer in 1912.

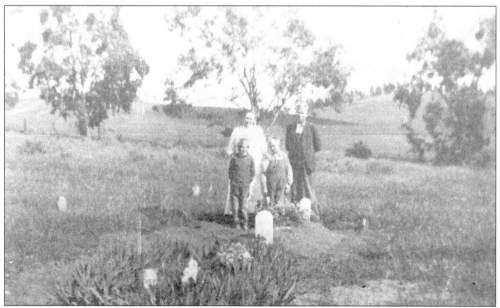

The San Marcos Cemetery Association was deeded land from the San Marcos Land Company for a cemetery in 1894 for $193.75. Ten-year-old Neva Pearl De Luce, a victim of diphtheria, was the first person buried there in 1895. Today, the cemetery holds the remains of many of San Marcos's pioneer families. Here, the Hanson family stands before the family plot in 1916.

Seeking a cure for his respiratory ailments, Simeon Morgan, a friend of the Hartshorn family, brought his wife and three children to San Marcos in 1893 and built what is now known simply as the Knob Hill House, seen above. Morgan's son Frank died in the house the next year. From 1927 to 1946, the Charles Fulton family rented the house for $15 a month. Theodore Fulton, pictured below with Madelaine and Louise Fulton, was fatally injured at the house in 1929 after trying to jump onto a moving car. The house is believed to be haunted by a playful spirit whose activities include moving rugs and playing harmonica. Leroy Fulton recalled finding a trunk containing Simeon Morgan's false teeth in the attic and said he could hear them chattering when nobody else was home.

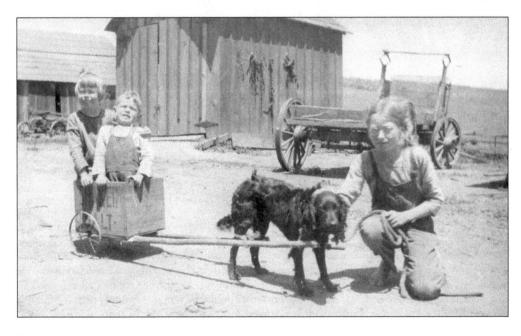

Five

FROM SUN UP TO SUN DOWN

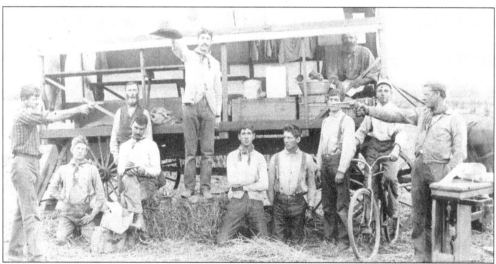

While working sunrise to sunset, six days a week, the Huchting hay baling crew, pictured in the early 1900s, took time out to play "shoot at the drop of a hat." On the far right is a scale used to weigh hay bales, with weights recorded on the large paper pad that sits on top. Behind, Claus Wehrmann sits in the cook wagon, which provided five meals a day.

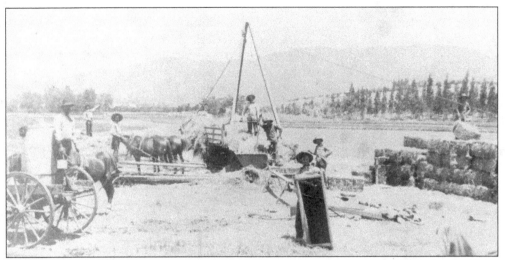

The process of hay baling in the Twin Oaks Valley is pictured here, using the Lightning Baler at center. Loose hay was placed inside the baler, and a horse-powered plunger pressed it until tightly packed. It was then removed using sharp hay hooks. To the left is the water wagon, filled with water from nearby streams.

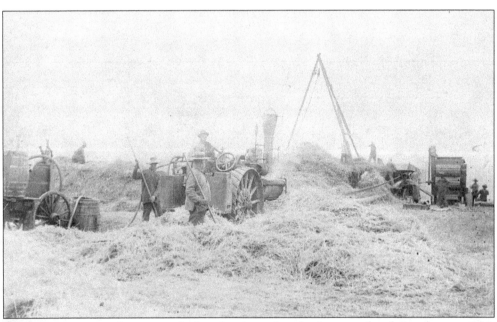

This baling crew is in the process of raking hay into piles after it was cut by a horse-drawn mower. Seated in the tractor is chief engineer George Witty, husband of Rosa Lee Borden. Described as "short and feisty," Witty was blind in one eye but was still allowed to drive a piece of heavy agricultural machinery.

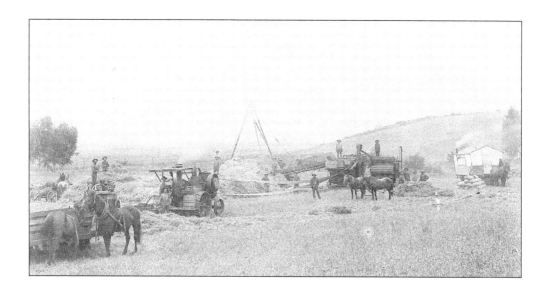

Pictured here on the Eliason Ranch, the Nordahl steam engine and threshing rig is in full operation. The threshing machine separated the grain from the husk, then cleaned and stacked the grain. Threshing machines were powered by steam, and the average threshing crew consisted of 18 to 20 men. The Nordahl family owned a threshing machine that was rented to other farmers, as many farmers bought machinery as joint ventures, trading time on the machine for labor. To the right is the cook wagon, pulled along with the crew by horse, from which was served meals cooked over a wood stove. Lee Gee, a Chinese cook for the threshing crew, takes a breath of fresh air below before preparation begins on one of the day's five meals.

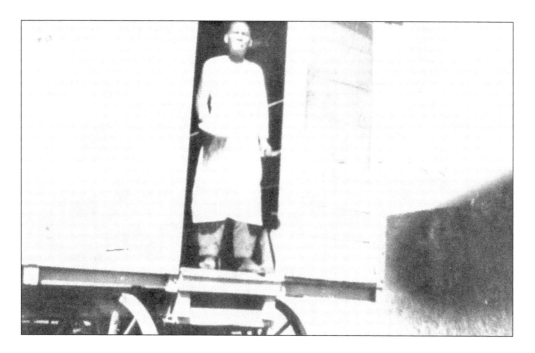

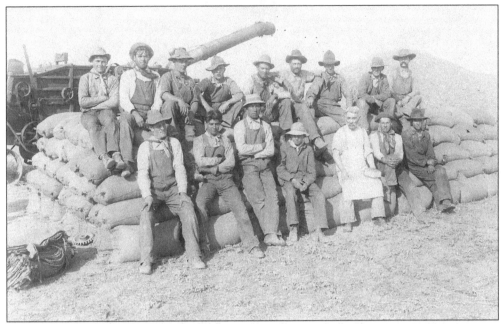

Pictured in 1912, the Nordahl threshing crew works on the Putnam Ranch. From left to right are (first row) Hans Hanson, the two Contreros brothers, Otto Pechstein, Mr. Fogarty the cook, John M. Hanson, and engineer Frank Snyder; (second row) Lawrence Zeller, Felix Quisquis from the San Pasqual Indian Reservation, Bruno Einer and Joseph "Ed" Bucher (both sack sewers, workers who sewed wheat sacks closed), "the fireman," unidentified, John S. Hanson, Everett Nulton, and Andrew William Nordahl.

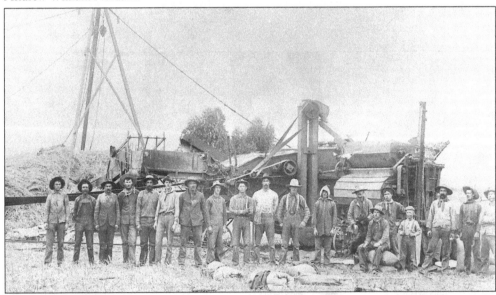

Around 1900, the Carver threshing rig crew poses for a photograph. From left to right are Oscar Nordahl, unidentified, Andrew William Nordahl, unidentified, John Borden, Fay Lamphord, Bart Carver, Erwin Bectle, Charles Fulton, Bill Thomas, Bill Mahr, Henry Mahr, Rudy Dorson, unidentified, Oscar Cochems, Edward Eliason (still very young), Gustave Eliason, John Hanson, and unidentified.

54

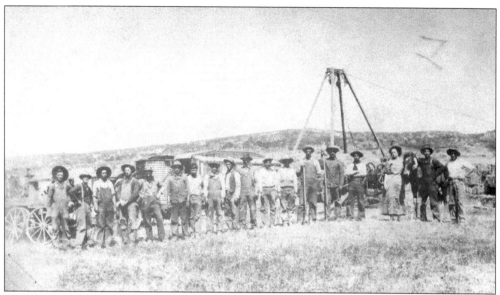

The Huchting brothers hay baling crew is posing around 1912. Third from the right with her arm wrapped around a horse is Sophie Huchting Cubbison, who gained cooking experience preparing meals for 40 ranch hands a day starting when she was 16. Sophie later became Mrs. Cubbison, the famous face of Mrs. Cubbison's Foods, specializing in stuffing, croutons, and meatloaf mixes.

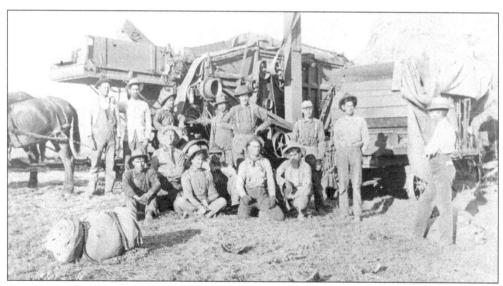

Standing at the far right is Everett Nulton, owner of the advanced grain separator shown here, used to separate wheat from other wild grains. Behind Nulton, John Thompson is seated on the trap wagon, which was used to carry tools and bedrolls. The crew, from left to right, are (first row) Frank Snyder, Bert Fulton, Clinton Rand, unidentified, Oscar Nordahl, and unidentified; (second row) John A. Borden, unidentified, John Hanson, unidentified, and ? Slaff.

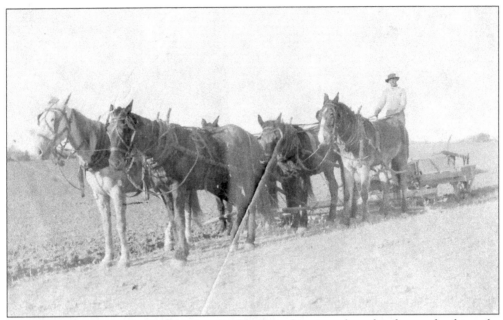

To reduce labor time and effort, farmers developed machinery such as this disc seeder driven by Walter Mahr and his team of horses. The disc seeder allowed soil to be tilled, dug, and overturned, while dropping seeds to be planted as the horses moved along. A field could be prepared for a new crop in a much shorter time than if prepared by hand.

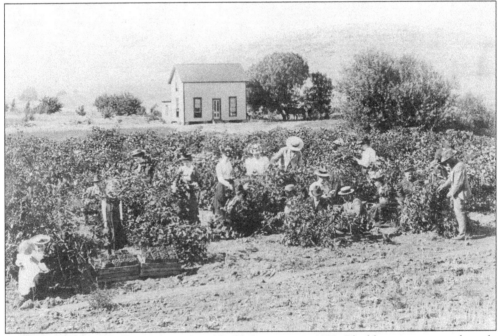

The James Barnes family harvests their blackberry crop in 1893. Blackberries were a relatively easy crop to produce, as many grew wild and could be made into jam and stored throughout the winter. On the left, baby Myrtle Astleford is held by her sister Ida. The background is now the location of the Twin Oaks Golf Course.

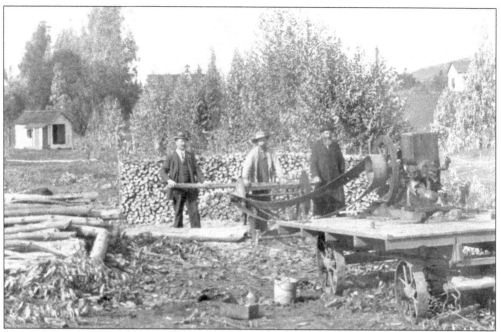

Men are seen here cutting eucalyptus wood for use as timber. In the early 1900s, eucalyptus was planted in mass quantities in California, as many believed the wood could be used for construction of railroads, buildings, and furniture. The wood proved to be unsuitable, as when cured it would twist, split, and become too hard to drive nails into.

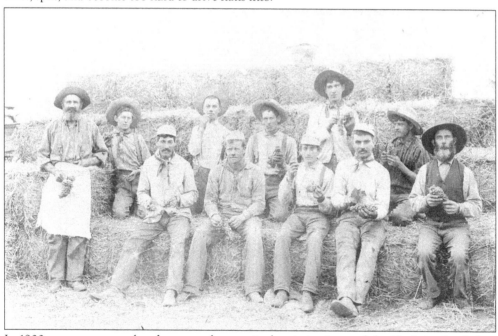

In 1900, grapes were an abundant crop that required no irrigation, and the Huchting hay baling crew enjoyed some for a snack while sitting on recently harvested hay bales. The crew, from left to right, is made up of cook Claus Wehrmann, Bert Fulton, two unidentified, John Hanson, Charles Fulton, Henry Mahr, unidentified, Henry Huchting, and August Huchting.

Around 1916 when this photograph was taken, many local farmers practiced dry farming, a process using no irrigation allowing crops to take deep roots to find existing moisture buried deep underneath the topsoil. Otto Grauskamp, a hired hand of the Merriam family, holds a box of tomatoes, a dry-farmed crop that would become one of San Marcos's predominant exports.

In addition to tomatoes, seen here in abundance on the Merriam property, local farmers grew citrus, apricots, plums, olives, and even watermelons. Grapes, used to make wine, brandy, and raisins, became a leading crop. Before child labor laws, during the summer children worked in raisin drying operations. A youngster with dexterity could process 100 trays in one day and net $3.

Six

SILK, MILK, CHICKENS, AND WAR

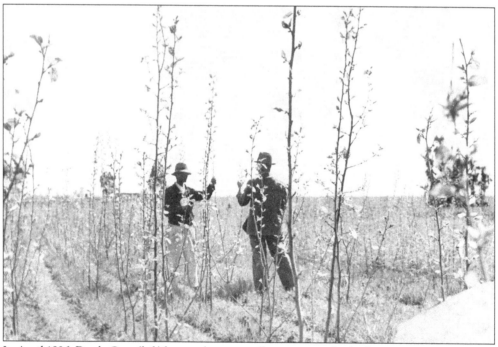

In April 1926, Donly Gray (left) began planting mulberry trees—the food source of silkworms—on the recently purchased 367-acre Big Bend Ranch near Mission Road and Mulberry Drive with the intent of building a silk plantation. With financial backing from a group of businessmen led by Glenn Hurst, a 50,000-square-foot silk mill was built, and opening day was an event crowded with city officials and movie stars.

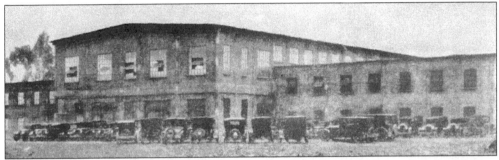

By January 1927, investors had formed a corporation under American Silk Factories Inc., forcing Donly Gray out of the company. Upon completion, the mill housed a nursery of up to 200,000 mulberry trees and over 100 employees tending to silkworms, birthed from eggs imported from France, Turkey, Egypt, and Sudan. The chamber of commerce that year put out a brochure proclaiming San Marcos "the land of silk and sunshine."

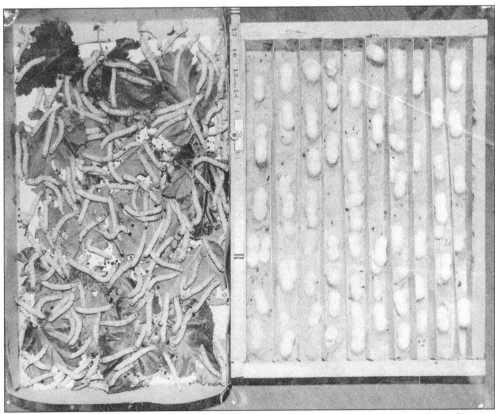

The left side of the factory was a hatchery, featuring three large incubators. On the right were four-by-two-foot sliding trays stacked five high, where worms were fed 24 hours a day until they spun cocoons, which were then oven baked to kill the butterflies inside, preserving the silk. It was claimed that the sound of silkworms chewing on mulberry leaves could be heard through the walls of the factory over a mile away.

By 1930, the factory was not able to compete with less expensive silk from Europe and Asia and the development of rayon as a substitute. In 1933, the company was declared bankrupt and the mill was shut down. All the mulberry trees once located on Mulberry Drive were declared dead during World War II when the federal government inquired about reopening the factory for production of silk powder bags.

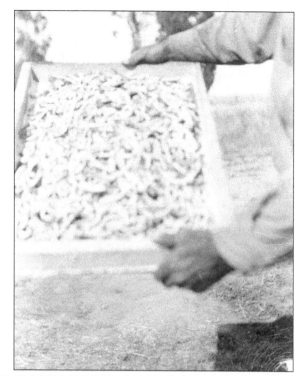

Art Tobin (left) was the owner of the Tobin Hatchery, a chicken breeding facility. The hatchery consisted of four electrically powered incubators with a capacity of 45,000 eggs, and seven battery-powered brooders, heated enclosures used to raise fowl, which could care for 4,000 chicks at one time. On the right, Betty Lou Astleford and Ward Rousch handle newly hatched baby chicks.

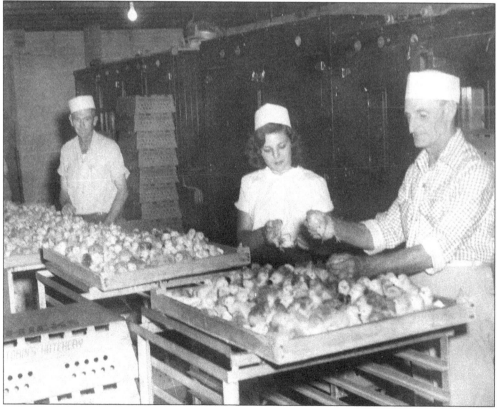

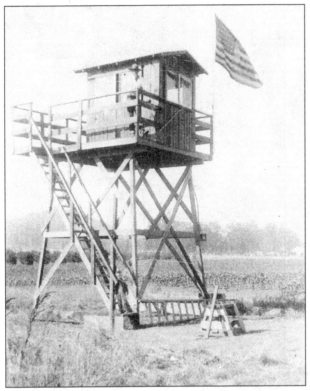

During World War II, Art Tobin, pictured with his son Mike Tobin, was appointed chief observer for the Army Air Corps in San Marcos. Tobin first constructed two shacks, then the tower shown here, to serve as observation posts to spot enemy aircraft. The post was on San Marcos Boulevard and Knoll Road and was patrolled 24 hours a day, often by neighborhood volunteers. Army sergeant Eddie Stoneback, in charge of all San Diego County observation posts, periodically stopped by to collect reports. On these days, the children celebrated with "airplane parties," where they were given cookies and punch and taught to recognize the different types of allied and enemy aircraft. Below, Jeanelle Hanson, unidentified, and Clara Morrison keep watch in front of the original post.

Fleeing religious persecution in Russia, the Prohoroff family, pictured above, settled in San Marcos in 1924 and first lived in an abandoned house in the area of what is now Lake San Marcos. "We kept moving . . . In one house we could look through the roof and see the stars . . . We never wore shoes," writes John Prohoroff in his memoirs. By 1945, the family started a chicken ranching business. "I believe I was the third commercial poultryman to put chickens up on wire," said Terenty Prohoroff. By 1961, the Prohoroff Egg Ranch was the largest egg producer in the world. The photograph below, from 1961, looks northeast towards the Prohoroff Poultry Farm, which at one time consisted of 557 acres and produced 328 million eggs a year.

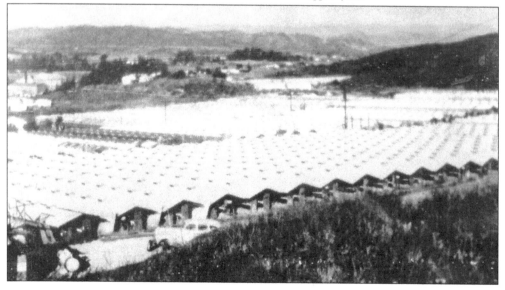

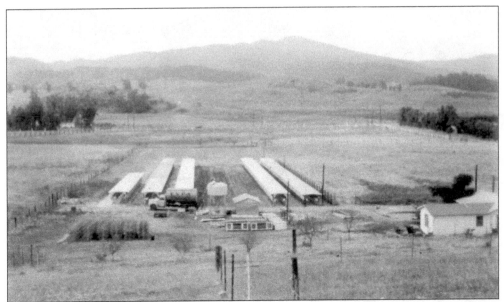

Hallack and Alma Cole bought the Oak Glen Ranch off Deer Springs Road in 1924. Originally the site of the Uhland homestead, the road was built following the streambed, which ran through land formerly named Uhland Canyon. Beginning in 1932, the Coles began raising turkeys and would open Coles' Turkey Ranch, seen here, a staple for local families' Thanksgivings.

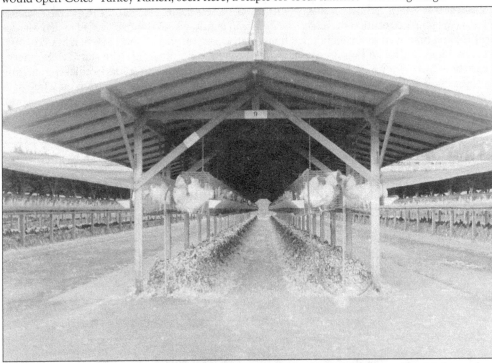

The Mahr family owned one of the first poultry farms in the San Marcos area. The Mahr poultry farm consisted of 100 acres just south of Discovery Road, purchased in 1914. Stanley Mahr, one of the area's original poultry farmers, spent all 91 years of his life in San Marcos. The Mahr farm was taken by eminent domain for development surrounding California State University San Marcos.

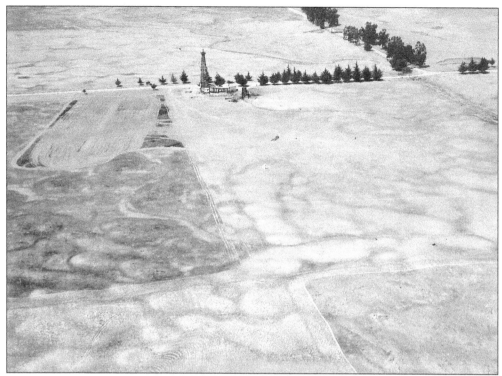

In 1926, Donald McAleese, an oil driller from Huntington Beach, teamed up with Henry W. Davenport, a German geologist, to develop two exploratory oil wells in the San Marcos area. The two wells, sunk on sites leased from farmers, were located at the corner of present Grand Avenue and Via Vera Cruz (pictured here in 1928), and near Nordahl Road. Neither well yielded any findings or profit.

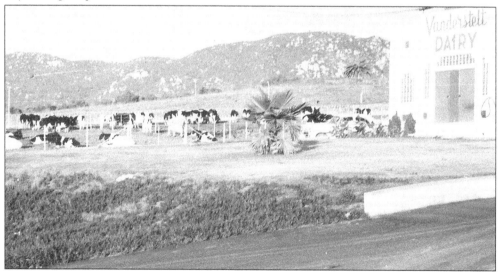

Pictured in 1961, the Vander Stelt Dairy consisted of 20 acres near La Cienega Road. An advertisement in the April 1960 issue of *Southern California Rancher* proclaimed, "Another big new dairy has been constructed in San Marcos adding to the area's undisputed claim to be the dairy capital of the North San Diego County."

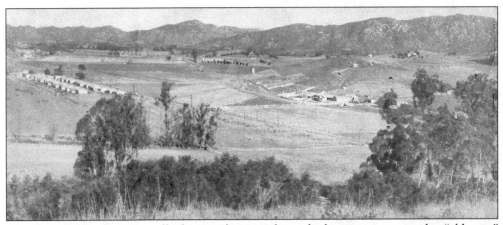

The Trussell Dairy was originally the site of a spring from which water was pumped to "old town" San Marcos for irrigation and domestic purposes. Ray Trussell Sr. bought the land in 1909, starting with a small herd of cows; by 1931, he was able to buy the herd of the Trent Dairy, consolidating the two largest dairies in the area. During World War II, the Trussell Dairy thrived with the high demand for fresh milk.

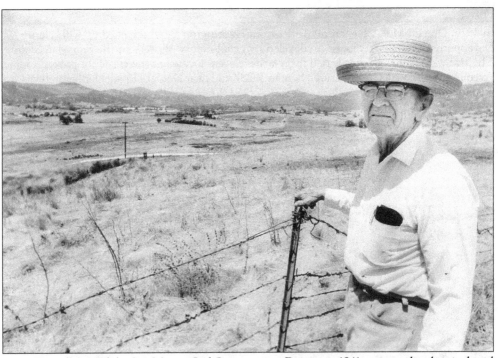

Amos Trussell formed the San Marcos Soil Conservation District in 1941, assisting local agricultural businesses with soil maps, technical and management assistance, erosion planning, and irrigation. Trussell served on the local fire commission, water board, and city council. This photograph from 1980 shows Trussell on his land, which was sold in 1989 and made into the Twin Oaks Golf Course.

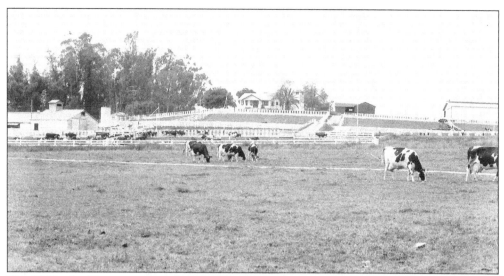

The Hollandia Dairy was started in 1956 by the DeJongs, a Dutch immigrant family who had arrived in San Marcos in 1949. At the time, Mission Road was the only paved street in town. The family originally owned a creamery in Escondido, and when enough money was saved, the family moved its business to the Mission Hills area.

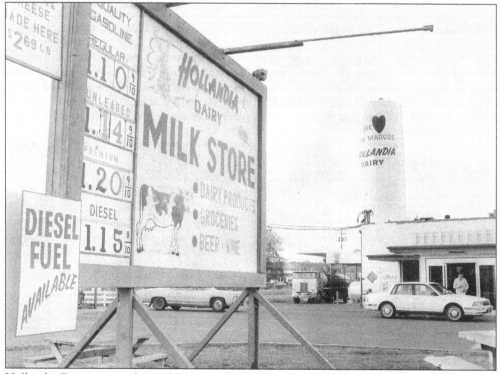

Hollandia Dairy, pictured in 1989, became a recognizable staple for San Marcos, complete with a general store and gas station. After being one of more than 100 dairies in the North County area in 1952, Hollandia Dairy would remain as one of the only dairies left in San Marcos, as most dairy businesses moved to California's Central Valley due to expansion limits and rising business costs.

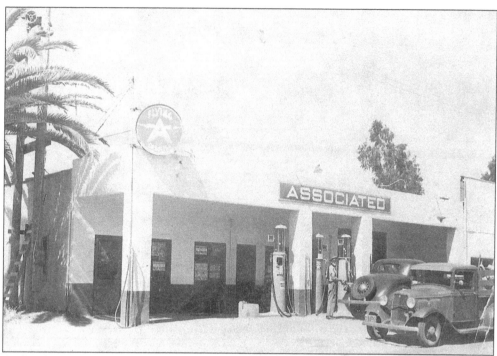

Fred Williams, pictured above pumping gas in 1930, worked at the Flying A Service Station—originally the San Marcos Garage—on Mission Road and Firebird Lane as an auto mechanic from 1928 until 1972. The garage was owned by "Pappy" Carpenter, father of Charles Carpenter, who in 1936 would organize the first volunteer fire department for San Marcos. Fred Williams was chosen to be the first volunteer fire chief, and the fire engine was stored inside the garage along with the department siren attached high above the garage, seen in the upper left corner. Below, Clifford Middleton and Bill Carpenter take a break to pose in front of the station's gas pumps around 1930.

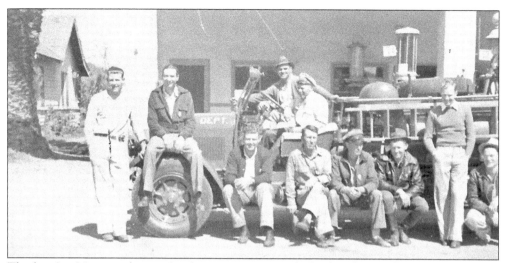

The first San Marcos volunteer fire department poses with the department's fire engine in front of "Pappy" Carpenter's service station, which is now the Veterans of Foreign Wars Hall on Mission Road. Seated in the engine are George Czarnek and Bill Carpenter. Standing from left to right are Jim Clark, fire chief Fred Williams, A.B. Clark, Bill Marvel, Dennis Mahr, Stanley Mahr, Hinky Jackson, and Homer Huchting.

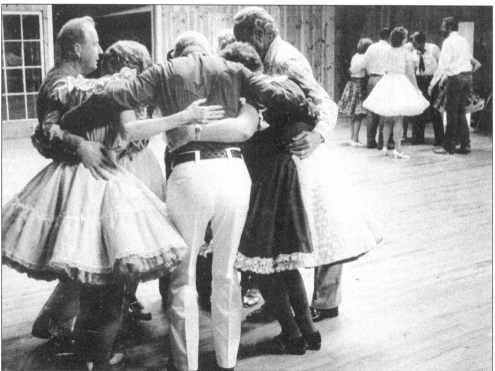

Fred Williams made his most lasting impression on San Marcos by opening the Williams Barn in 1951. While the city scrapped his original plan to build a square dance hall, as square dancing was closely associated with liquor and rowdiness, Williams instead built a barn with its purpose open to interpretation. Williams and his wife Frances called square dances in the barn, pictured here, for nearly 30 years.

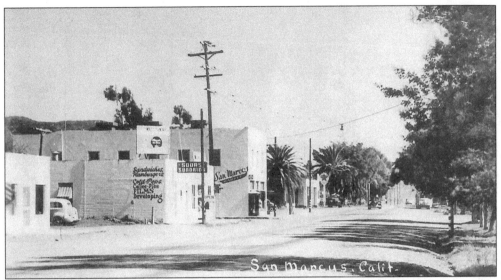

This photograph, believed to have been taken sometime between the late 1940s and early 1950s, looks east down Mission Road to the intersection of Pico Avenue. The original San Marcos Market and post office, which had been built on the spot in 1907, burned down in 1924 only to be rebuilt in nearly the same design almost immediately after.

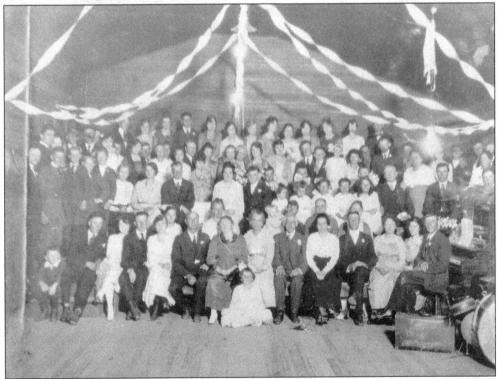

Pictured here in 1923 is the Promotion Hall, which stood above the San Marcos Market. With a second story built in 1907 featuring hardwood floors, the spot was perfect for holding community dances. Local musician Jane "Tiny" Putnam, whose home was regarded as a gathering place for local musicians, was known to play piano for the dances.

In the 1920s and 1930s, Myron and Nellie Kreisler had a general store on the corner of Pico Avenue and Autumn Drive. The Kreislers' store featured a vast array of merchandise, including factory-canned goods and electric fans, displayed below on a shelf above the door in back, and custom built brooms, made by a machine the family owned. Myron Kreisler kept at least three barrels of olives outside the store for processing until they were ready to be sold. Biscuits and sweet pastries were entrancingly and intentionally located at children's eye levels. The Krieslers lived behind the store and were always available if a neighbor ran out of sugar while cooking a cake. The building was destroyed in 1994 and is now the location of the San Marcos Unified School District Office.

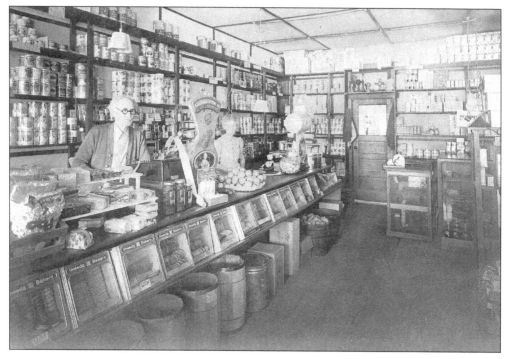

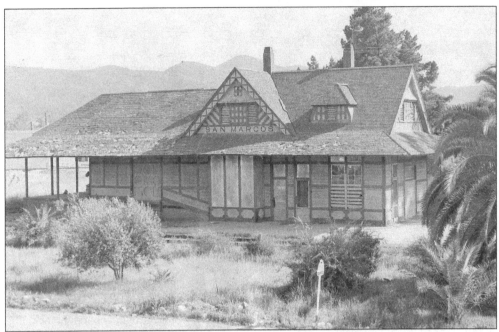

The San Marcos Train Depot was closed after the Santa Fe Railroad ceased passenger operations in 1946 and stood abandoned for 10 years. It appeared this way until 1956 when it was sold for $100 and torn down. The San Marcos Grange used some pieces of scrap material from the depot to construct the new Grange Hall on Mission Road.

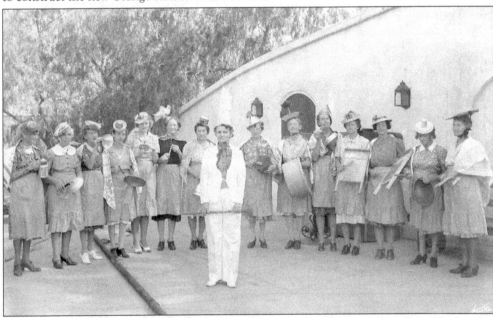

The Ladies of the San Marcos Grange kitchen band, also known as the Patrons of Husbandry, are pictured in 1940. Standing in the center, wearing white, is bandleader Elizabeth "Lizzy" Huchting, prepared to lead a musical march. Other members in unknown order include Doris Kreisler, Verna Radcliff, Emma McAleese, Rebecca Chambers, Clara Morrison, Emily Johnson, Gertrude Boucher, Myra Wilkinson, and Ruth Uhland.

C.W. "Red" Neill, pictured here on his ranch, was a nationally recognized horse trainer and cattle rancher and owner of Neill Stables, once located on Beverly Road, now known as Smilax Road. Neill was also a member of the Escondido Mounted Posse, an equestrian patrol unit created in 1948 to back up the Escondido Police Department, which had jurisdiction over San Marcos until 1963.

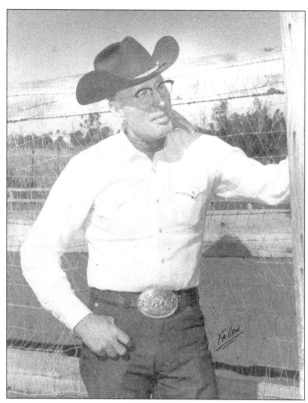

This photograph from 1956 shows the ground breaking for the Bell Milling Corporation's feed mill at Barham Drive and Highway 78. The mill produced 300 tons of animal feed daily. From left to right are Harry Bartlett, Wilbur Bartlett, Bruce Bell, Albert R. Padille, and Jim Downing, along with W.D. Stewart, R.R. Stane, and G.K. Hafly, members of a Santa Fe Railroad survey crew commissioned to build a railroad spur to the mill.

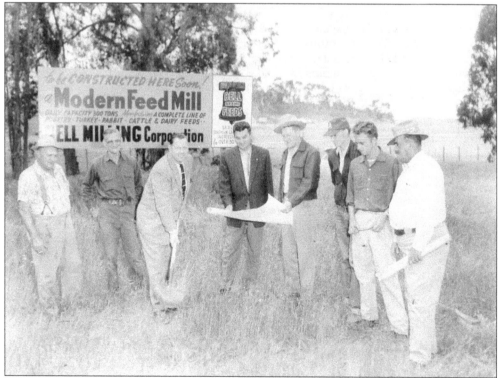

While San Marcos was always touted for its temperate weather with no extremes of hot or cold, snow has been recorded at least three times in the area's history. The first came in January of 1882, when Robert Kelly reported that a cold northwest wind blew in, turning the San Marcos Hills white for two weeks and causing 2,000 head of sheep to die. His son Charles Kelly reported that while out driving mules with John Barham and John Isbell, snow could be seen on Catalina

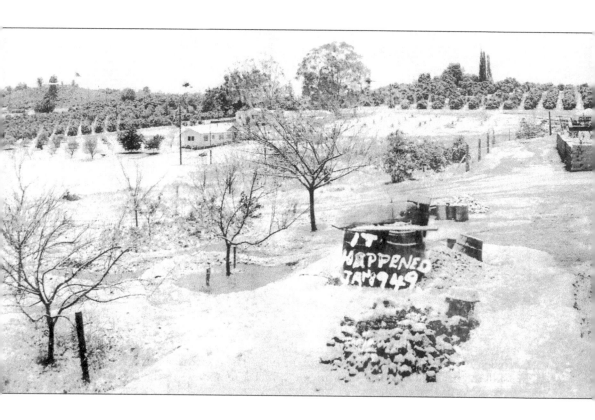

Island. The second, but first official recorded snow, fell in 1949, pictured above looking north from Valpreda Road. The third and most recent snowstorm dropped about three feet in 1967. Record high temperature days would have looked similar to the image below, looking south just west of Palomar College toward the Cerro de las Posas Mountains.

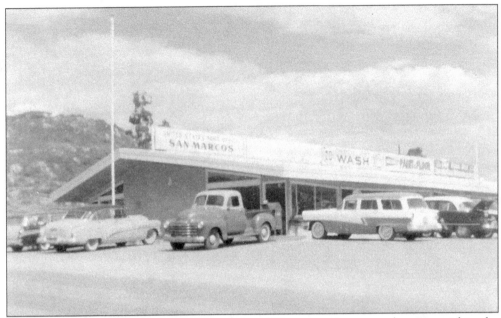

On New Year's Day 1950, the San Marcos Post Office moved to a new location within the Serendipity Mall off San Marcos Boulevard. In 1959, the same year of this photograph, Albert Richardson, who would become postmaster in 1973, began working for the post office.

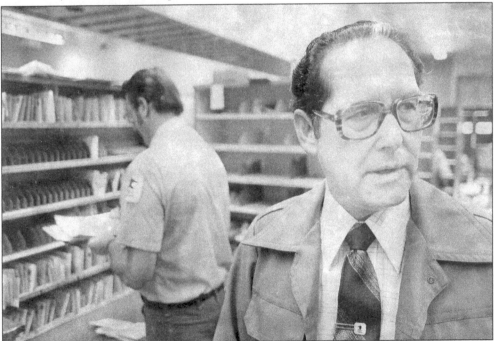

Richardson, shown here around 1978, recalled that one of his strangest deliveries involved a beekeeper up near Mount Whitney. "During the bee season, he'd ship as many as 50 to 60 boxes of bees . . . a little bit bigger than a shoebox," he said. The boxes full of live bees were shipped to Los Angeles, but there would always be "tag along bees outside the post office," Richardson said, adding that "one box broke open in the Los Angeles post office."

Seven

MAKING IT OFFICIAL

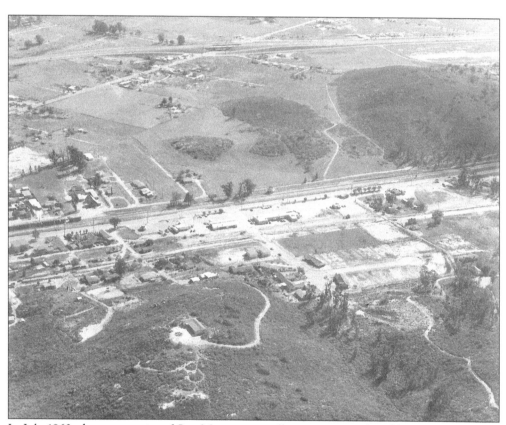

In July 1960, the community of San Marcos was still unincorporated and had a population of approximately 3,000 people. That month, construction began on a freeway running between Oceanside and Escondido, State Highway 78. Looking north, this photograph from 1965 shows the completed freeway at the top of the picture with Mission Road running adjacent through the center.

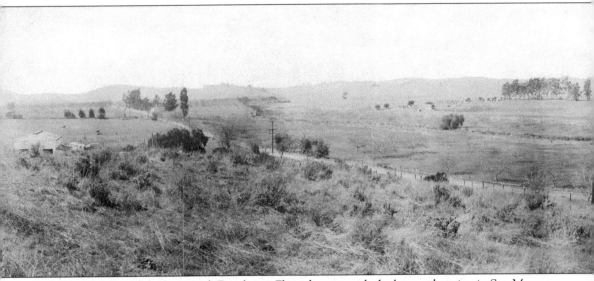

This photograph looks towards Desolation Flats, the area with the lowest elevation in San Marcos. A car drives west along San Marcos Boulevard, which cuts horizontally through the center of the photograph, near Discovery Street and Via Vera Cruz, then known as Arctic Street. Strangely, this area would be one of the leading factors in San Marcos's decision to incorporate as a city in 1963. With Escondido thriving and encroaching upon the area, residents feared annexation

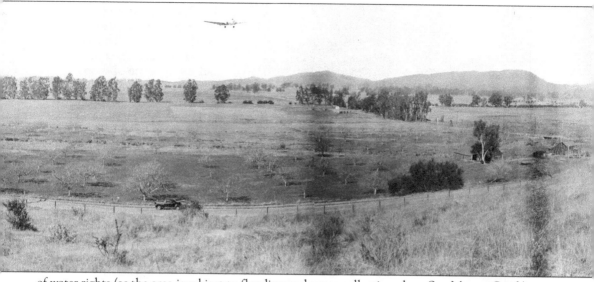

of water rights (as the area is subject to flooding and water collection along San Marcos Creek), along with railroad land. Also fearing annexation from Vista, the City of San Marcos incorporated as a "general law city of 3,200 persons" on January 28, 1963, just four hours after the official incorporation of Vista.

The first mayor of San Marcos was William Buelow, who held the first city council meetings on the second floor of his barbershop at 316 Mission Road. Buelow recollected, "We couldn't afford desks and chairs, so we sat behind a picnic table on a wooden bench." The first city clerk was Betty Ferguson, currently the longest tenured, and first female, city official.

This photograph of Richland Road in 1963 displays the open space and country feel still enjoyed by new city residents. This same year, Carolyn Read bought and began restoration on the former Borden residence at 1043 Richland Road (center), which at the time was abandoned and a popular roost for pigeons.

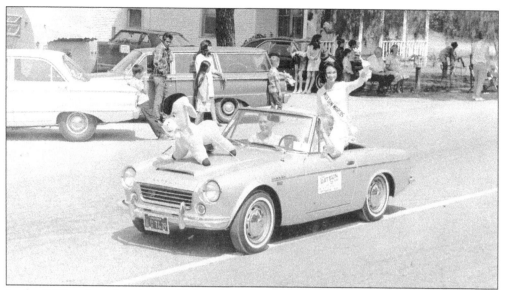

In the 1960s, when the city would shut down San Marcos Boulevard—still Encinitas Road at the time—for a parade, little traffic or business was affected. Miss San Marcos of 1968, Belita Felgin, waves to an unseen crowd as neighbors sit in chairs on their front lawn to take in the day's festivities.

The first modern San Marcos City Hall was the former Escondido National Bank that the city bought for under $21,000. The building was moved from Escondido to the corner of Richmar Avenue and Twin Oaks Valley Road in 1968. Pictured on the left is the city's first elected mayor "Doc" Burton, who would be the first mayor to lead the city council in the new building.

Into the 1950s, San Marcos still depended on wells as its only source of water. In dire need of a domestic water system, the San Marcos County Water District was approved in 1955 to construct a public water piping system. In 1956, when the first flow of Colorado River water arrived, Gerald McAleese, who had made the first financial donation toward the water district, was doused by a fire hose. Pictured above in the 1970s, the San Marcos County Water District office was located on San Marcos Boulevard until 1989, when the organization was renamed the Vallecitos Water District with a new office at 201 Vallecitos de Oro. Pictured below in 1986, workers construct a new water piping tube beneath San Marcos Boulevard.

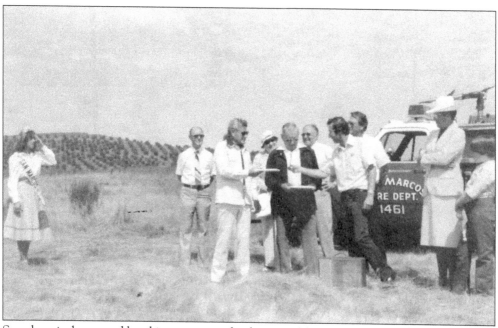

Seen here is the ground breaking ceremony for the second fire station in San Marcos on Rancho Santa Fe Road. Miss San Marcos Leslie Lawe (left) looks on as Charles Carpenter (third from right) and Stanley Mahr (fifth from right) receive honorary plaques from Councilman Norman Bucher (seventh from right) for their duties in the early fire department. The fire engine pictured was still in use up until 1978.

In 1970, William Carroll, pictured at far right with his family, founded the community newspaper the *San Marcos Outlook*, and three years later he purchased the 1910 schoolhouse, which he moved to Grand Avenue and turned into the newspaper's office. Carroll is also known for being the first photographer of Norma Jean Mortenson, later Marilyn Monroe, who hired him for her first photo shoot in Santa Monica for $20.

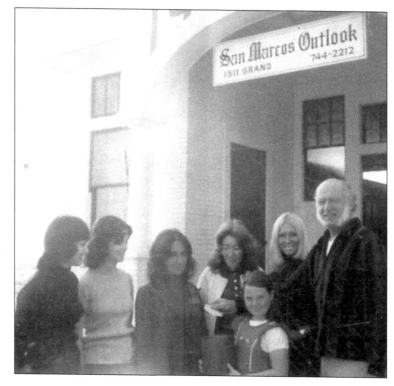

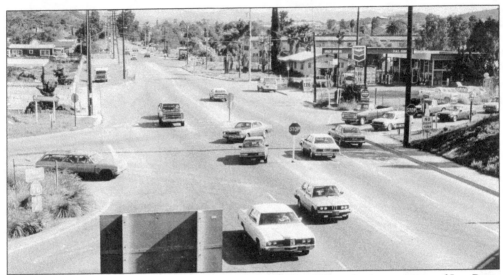

San Marcos did not install a traffic light until April 25, 1974, at the intersection of Las Posas and Mission Roads. This photograph from 1988 looks east down San Marcos Boulevard near the Highway 78 overpass, when the intersection was still a four-way stop. On the right, the price of gasoline can be seen at $1.06 a gallon.

Photographed in 1975, Madrid Manor was one of San Marcos's many mobile home parks built in the 1960s. In 1970, the city issued a moratorium on construction of new mobile home parks. In turn, the large population of mobile home residents voted out two proponents of the moratorium from the city council in 1972.

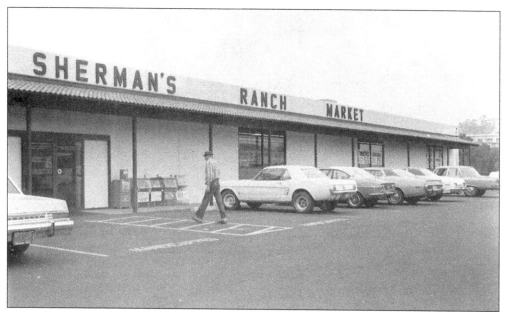

Charlie Sherman moved to San Marcos in 1953 and started a small egg ranch on Cassou Road. He opened a market featuring not only eggs but also a bakery, meat market, and produce section. In 1977, the market moved to its new location on San Marcos Boulevard. Pictured in March 1978, Leland Astleford enters the new store.

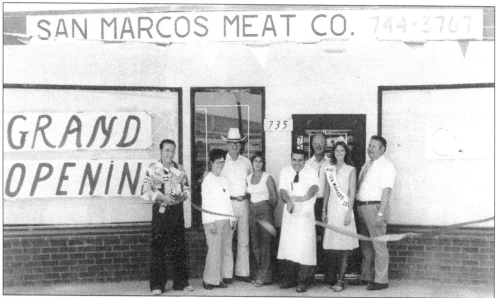

Pictured July 21, 1977, at the reopening of the San Marcos Meat Company, sixth from left is Chester Ballard, three-time president of the San Marcos Chamber of Commerce. Ballard made two attempts at retirement, later to be called back to lead in place of scandalized presidents, including an escaped convict from Arizona. The newest owner of the meat company, Peter Valdez, is pictured in the white apron.

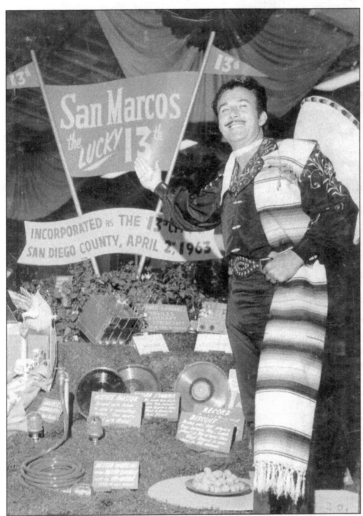

By the mid-1970s, the population of San Marcos had risen to well over 15,000, making it the third fastest growing city in the state. On the "lucky" 13th anniversary of incorporation, Don Diego (left) stands with the city's exhibit at the Del Mar Fair, although the date of incorporation displayed is incorrect. The next year, as seen below, the city put together an exhibit proclaiming its prominence as "a well rounded community." Emphasized was the city's dedication to education, focused around the increasingly popular Palomar Community College. Poultry, dairying, and agriculture were also featured as the city's original and still-important assets.

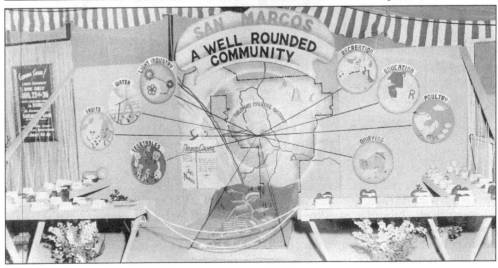

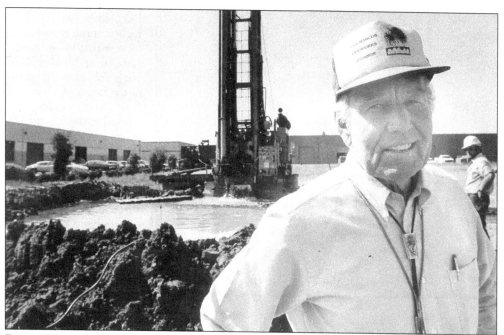

Former Navy SEAL and world champion swimmer James Eubank began life in North County as a fruit stand owner on San Marcos Boulevard. Eubank struck two water wells on his land and became a voice for developing a local water source from San Marcos Creek, which he claimed was a "creek full of malaria pools" but could "provide a source of water" within the region.

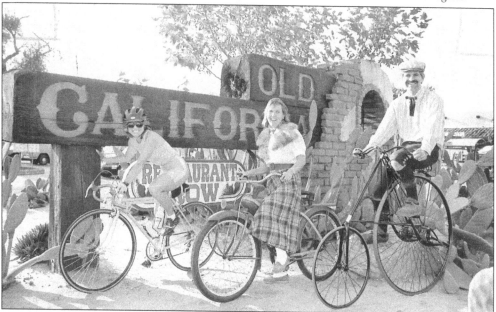

Eubank was regarded foremost for being the developer of Old California Restaurant Row. Conceived as an idea to change the image of San Marcos, which Eubank claimed was "the heart of North County," to the old Spanish rancho style, many claimed his project would fail and joked the "official bird of San Marcos was the horsefly." Opened in 1978, Restaurant Row remains one of San Marcos's most popular destinations.

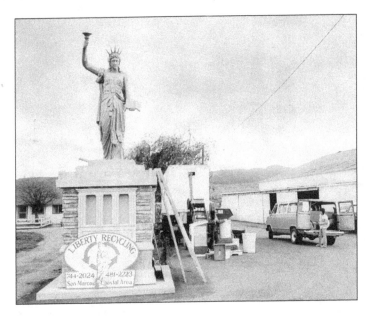

Pictured in 1984, the replica of the Statue of Liberty that today stands across from Mission Hills High School at the gates of the Liberty RV and Boat Depot, was first erected at the Liberty Motel in Leucadia during the 1920s. The statue was moved to Oceanside and Escondido before being placed during the 1980s in front of the Liberty Recycling Plant, named after the statue by owner Arie DeJong.

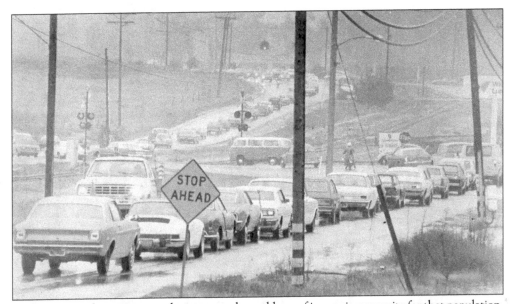

With a constantly growing population came the problems of increasing capacity for that population. Road widening and expansions have become commonplace in San Marcos in recent years in order to avoid the traffic problems seen here in 1978 on the route approaching Palomar College. Traffic problems caused Mayor Jim Desmond to joke in 2013 that the city featured "free parking" on Highway 78.

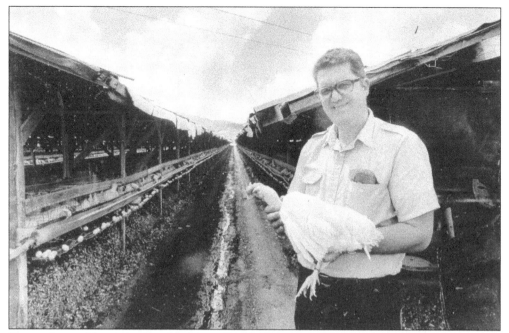

Routinely, neighbors complained to city officials about the odors coming from the Prohoroff Egg Ranch. While the smell of 375,000 pounds of manure a day may have been displeasing, the family made great strides by developing a system to convert waste to usable protein. This photograph of Dr. Paul Miller shows the immensity of but a single row of egg-laying chickens.

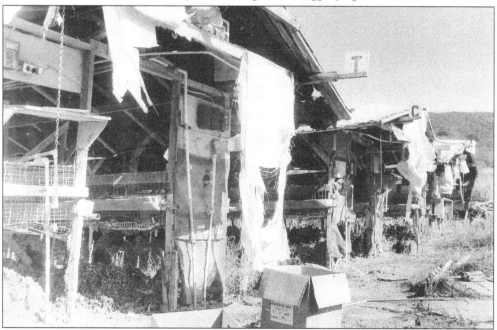

In 1985, after downsizing for a number of years, the Prohoroff Egg Ranch was sold to local investors and abandoned, leaving behind the ghostly remains of a once thriving business. In 1988, the trustees of California State University San Marcos bought 304 acres of the former ranch for $10.6 million for construction of a new campus.

Pictured in 1992, Jonathan Olguin, age two, and Reyna Galvan, age six, play in the playground off Twin Oaks Valley Road that would become the San Marcos Civic Center in 1994. The Civic Center now holds city hall, a community center, and the city library and is located in conjunction with Civic Center Station, a stop on the Sprinter Light Rail, which started operations in 2008.

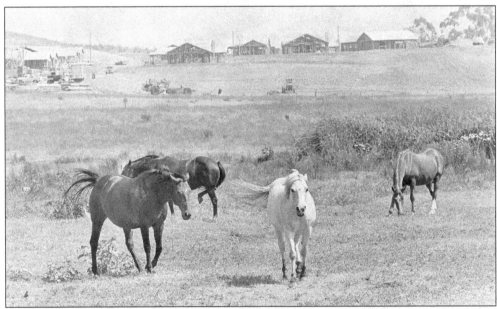

As of the 2010 census, the San Marcos population stands at 83,781 and is expected to reach over 100,000 by 2020. While the community has grown and developed immensely, a rural character remains, acknowledging a century gone by. In 1988, horses graze at Last Chance Ranch off Twin Oaks Valley Road as development looms behind.

Eight

THE HUB OF INTELLECTUALITY

The first San Marcos School District was formed in Twin Oaks Valley in August 1881. Classes were first held in the home of E.L. Richards for six months until the original San Marcos School (seen here) was built in the spring of 1882 on the property of Thomas Isbell, just southwest of present Pechstein Dam. When area districts were realigned in 1886, residents hauled the school by mules to the Merriam Ranch.

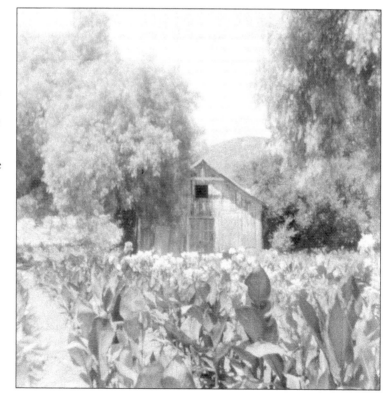

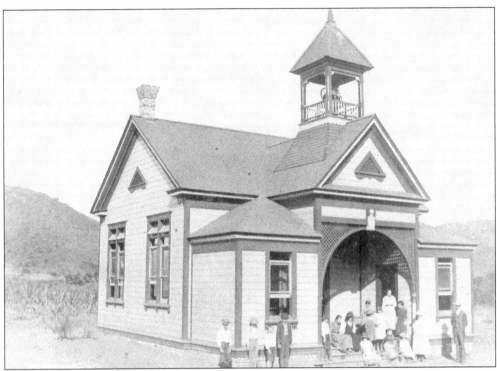

In 1887, the San Marcos School District changed its name to the Twin Oaks School District and in 1890 bought two acres on Deer Springs Road for $50 from the San Marcos Land Company. The tiny schoolhouse was once again moved to this new property. The teacher was Millie J. Littlefield who was paid $60 a month. The next year, construction was completed on the Twin Oaks School, pictured here.

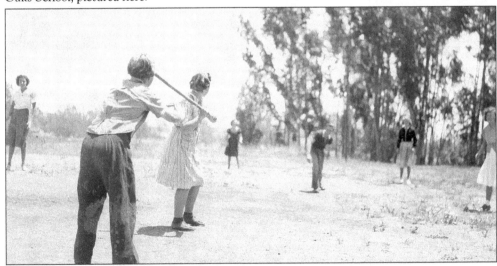

School children enjoy a graduation day softball game. The much larger Twin Oaks School replaced the tiny schoolhouse, which was once again hauled back to the Merriam Ranch, where it stood until 1974. The Twin Oaks School operated under the Twin Oaks School District until 1939, before being taken over by the Escondido District and closed in 1944, although the building still stands.

Perched atop a scenic hill on what is now Woodland Parkway, the Richland School was originally built in 1889 as a one-room schoolhouse to serve the community of Richland. In 1890, a second room was added in order to split up grades one through four and grades five through eight. The school was used for various community gatherings including Swedish church services on Sundays in the 1890s.

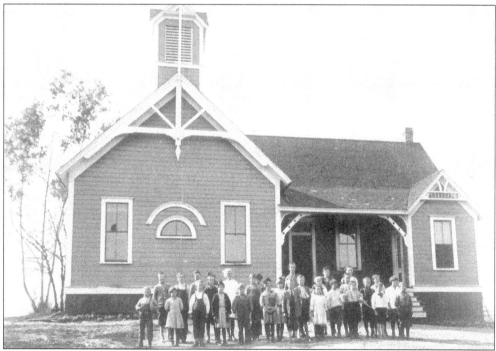

The Richland School, shown here in 1910, was known for its distinctive Gothic Revival–style belfry, featuring the first school bell in the San Marcos area. The tolling of the bell signified an end to the hour of recess, and children would scramble back up the steep hill to resume schooling. Lacking running water until the 1930s, a water bucket with a dipper was used for refreshment.

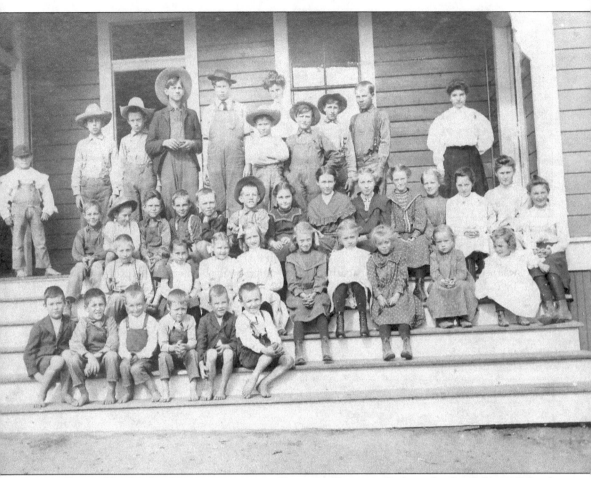

The Richland School District was originally operated separately from the San Marcos School District with initial board members including Reynold Boscomb Borden, William Justice, and two permanent teachers. Pictured here is the entire Richland School class of 1907, first through eighth grades. From left to right are (first row) Ernest Sapp, Ronald Johnston, Nealie Boyle, Bobby Brown, George Sapp, and Hugh Boyle; (second row) Wendell French, Eunice Risdon, Emily Sapp, Viva Sharp, Blenda Hilloff, Alice Gall, Linda Helloff, Matilda Hanson, and Stella Boyle; (third row) Andy Hanson, Ray Erickson, Bill Bucher, Lawrence Reher, Nate Ridson, Claude Erickson, Essie White, Myrtle Astleford, Edith French, Bluebell Fulton, Hilma Hanson, Frances Lewis, Helen Brown, and Jennie Boyle; (fourth row) Eddie Bucher, Oliver Erickson, John Hanson, and teacher Jennie Yeager; (fifth row) George Mahr, Everett Hall, Erskin Gall, Carl Erickson, John Sapp, Tommy Gailey, and teacher Mrs. Stevenson.

In 1923, the community of Richland remained very small with an eighth grade graduating class of only four girls. The four graduates from left to right are Madge Borden, Delia Van Dorin, Louise Fulton (who was also valedictorian), and Phyllis Blake. Standing behind them on the left is first-through-fourth-grade teacher Miss Carter and, on the right, fifth-through-eighth-grade teacher Mrs. Stevenson.

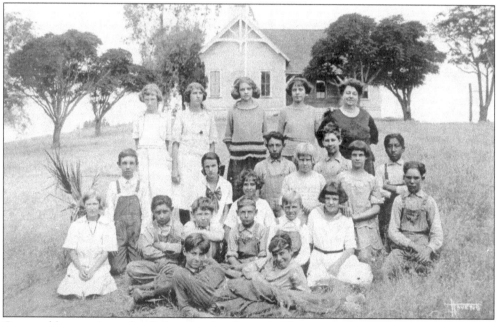

Captured by prominent local photographer Louis A. Havens are the 1923 upper grades of the Richland School. The school was first closed in 1947, reopened in 1951 to house an overflow of elementary school students, and ceased public education again in 1957. When Richland Elementary was opened in 1962, the schoolhouse became known as the Old Richland School and still stands today in the same location.

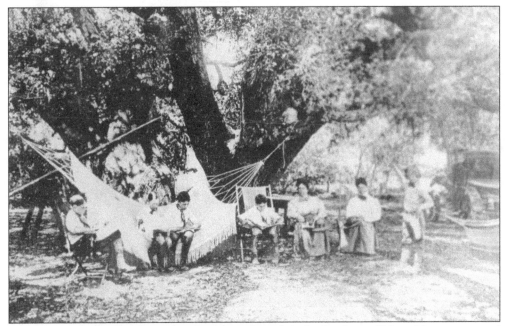

Virginia Merriam Jordan (second or third from the right), the daughter of Major Merriam, started a boarding school for boys aged eight to fifteen out of her home in 1904. One of the first private schools in Southern California, the camp style school was run by Jordan with her husband Leonard Jordan. Students are seen here reading under the Twin Oaks Trees that were a normal study spot.

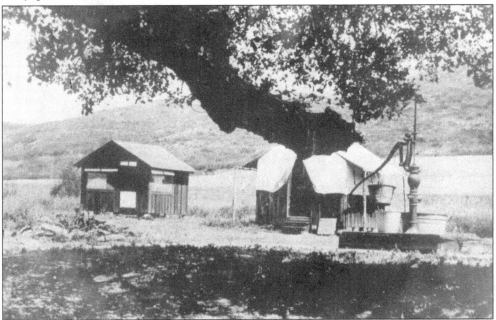

An eight-month school term from October to May cost $750 per student. Pupils attended class and ate dinner in a main house, while sleeping in individual tent houses, pictured here. A brochure for prospective students explained that the school aims "toward health and happiness, toward unselfish, manly character, and toward thorough and self reliant habits."

96

The Virginia Jordan School curriculum consisted of American, English, Greek, and Roman history, English literature and composition, mathematics, geography, drawing and painting, Latin, German, and Spanish. After academic school let out, horseback riding, ranch work, gardening, and lasso throwing were daily activities to "develop mental and physical faculties at the same time." Target practice, "carefully supervised," was held once a week.

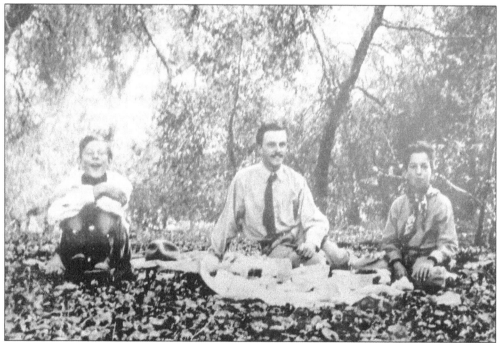

Two camping vacations were included. In autumn, a short trip to the beach in Oceanside or Del Mar was taken, and in spring a "longer, rougher" trip to the mountains at Pauma Creek was offered. The school claimed to be "well adapted to boys wishing to avoid the rigors of an Eastern winter" and drew almost half its students from Detroit, Michigan.

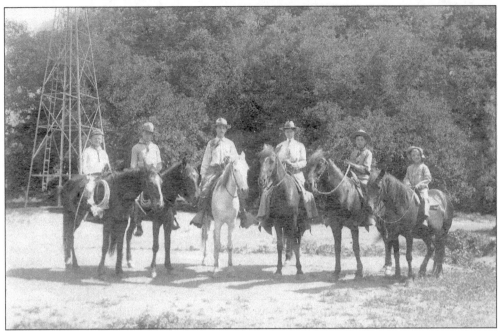

The school's brochure also noted that a health exam, along with "satisfactory evidence . . . of good character and average ability," must be submitted before an application would be accepted. While admittance seemed tough, living conditions would seem to not be excessively rugged, as student Donald Carson gained 24 pounds over one season. The Jordans closed the school in 1914, possibly after receiving a hefty inheritance after the death of Major Merriam.

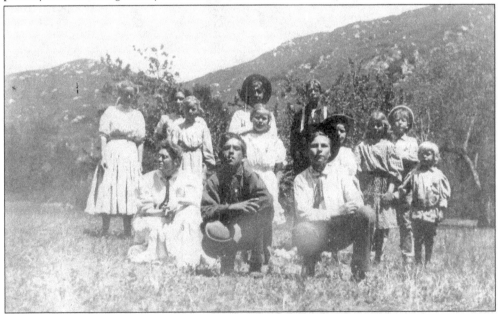

The first public school to serve the original San Marcos township was the Barham Schoolhouse, which was relocated from the defunct Barham township to the northeast corner of Rancho Santa Fe Road and La Mirada Drive in 1889. In 1895, a new school known as the San Marcos Grammar School was constructed for $2,500. Students pose here while attending the 1908 school picnic.

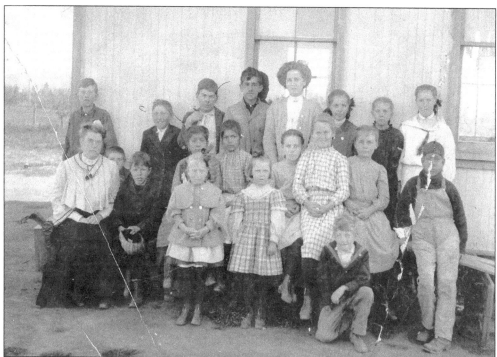

The school building pictured here stood until 1908, when along with the rest of the town of "old" San Marcos, it was to be moved by mules to the new town site near the railroad tracks. The night before the scheduled move, the schoolhouse inexplicably burned to the ground, leaving many to assume the burning was an act of arson by begrudged old San Marcos residents.

San Marcos Grammar School teacher Helen B. Rodgers sent out this Christmas greeting booklet, dated December 25, 1908, to her students to commemorate the holidays. Pupils for the year included multiple members of the Hall, Harrison, Nicholson, Eliason, Sheets, Mahr, Eggleton, French, Hoblit, Cheatham, and McNealy families.

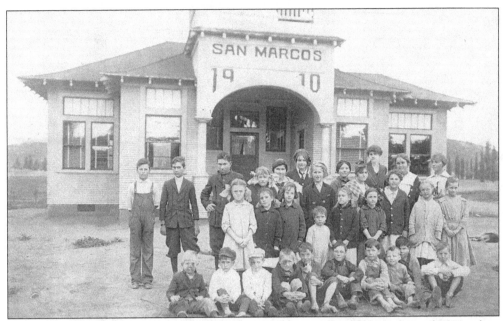

School was held for a short time in a business residence on Grand Avenue until 1910, when the aptly named 1910 Schoolhouse was built by H.W. Hall on the north side of San Marcos Boulevard. Local historian William Carroll recorded that a turnstile was originally installed to keep animals out of the premises but was soon removed due to so many students riding horses and mules to school.

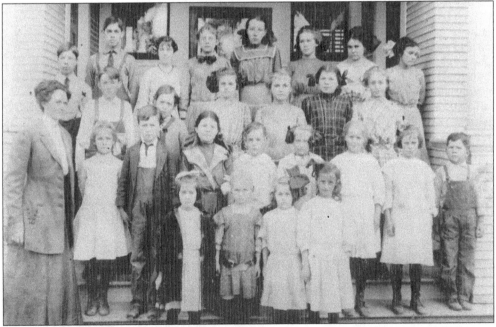

Mary Young Conners (front, left) passed through San Marcos in the summer of 1924 while moving from Colorado to San Diego, and decided to take a teaching job at the 1910 Schoolhouse only a few months later. Conners taught grades four through eight while studying at San Diego State College; by 1938, she was principal of San Marcos Elementary School.

Amerila Lamphere (center) taught this first-through-third-grade class from 1928 to 1929. From left to right are (first row) Florence Pike, Bessie Marvel, unidentified, Helen Haessler, Katie May Trussell, Opal McPherson, unidentified, and Marjorie Kuhn; (second row) Ryziki Tannaka, Mina Yammamato, unidentified, Ruby Yasakocha, Mabel Nunez, Genevive Nunez, Emma Lou Rice, and Muriel Humphrey; (third row) Clifford Johnston, Manuel Druan, Gerald Davenport, Edwin Egley, Earl Humphrey, Henry Egley, and George Garcia.

In 1927, Clarence Mersman, pictured on the left, would drive his four children to the 1910 Schoolhouse in their Durant automobile. The school board paid Mersman to replace the seats of his car (pictured) with wooden benches and make several trips to pick up other children. In 1930, the board bought him a 1930 Model A Ford, which he drove as the local school bus until World War II.

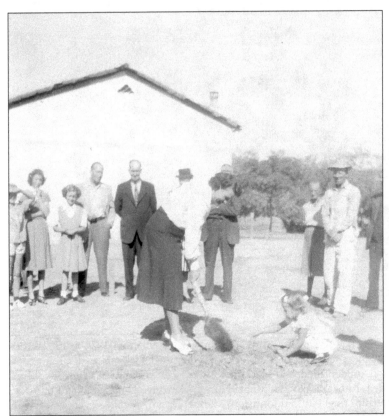

Pictured here in 1940 with a shovel, Mary Young Conners was honored at the dedication of a community center for which she had secured a grant from the Rosenburg Foundation. The building, dubbed the Mary Young Conners Hall, was built by the Works Progress Administration, and served as an auditorium and office for San Marcos Elementary. The building now houses the museum for the San Marcos Historical Society.

By 1929, three rooms were added to the 1910 Schoolhouse. After the addition of the Mary Young Conners Hall, additional classrooms were added in 1948 and 1955, pictured here. The schoolhouse seen on the left was deemed unsafe in 1962 and moved to a lot on the corner of Grand Avenue and Rancho Santa Fe Road.

In 1946, the San Marcos School District and Richland School District decided to join together and form the Rich-Mar School District. San Marcos Elementary changed its name to Rich-Mar Union School. Above, students at newly renamed Rich-Mar Union School participate in a kite-making contest. Below, the 1948 Rich-Mar Union School eighth grade class is poised for a change of scenery. San Marcos opened San Marcos Junior High in 1966 for seventh and eighth grades with the moniker the Crusaders. By its second year, the school had a publication dubbed *The Tales of the Fighting Crusader*, featuring articles such as the self-help column "Dear Blab." In the first edition, editor Brad Chamberlain wrote, "We have moved into a new school building. . . . Recently the large dirt pile on the athletic field was torn down and spread out."

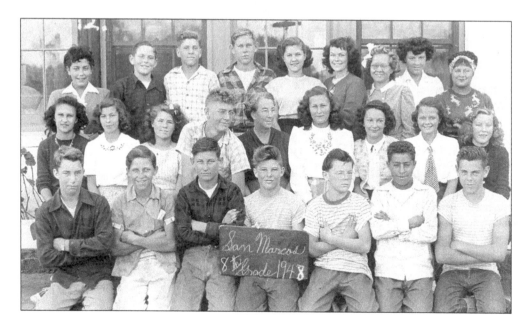

Harry Orum "Pop" Bishop, pictured on the Rich-Mar Union School playground, took over as bus driver for Rich-Mar Elementary at the start of World War II. Bishop once received the safest driver of the month award for the entire country and was awarded locally for consistently driving without a mishap.

After 18 years, Harry Orum "Pop" Bishop, sitting here wearing a bowtie, retired after the 1959 school year. His retirement party was held at the Williams Barn, and he was given a 23-jewel watch and a power saw as retirement gifts, donated by Gerald McAleese who owned the local feed and supply store.

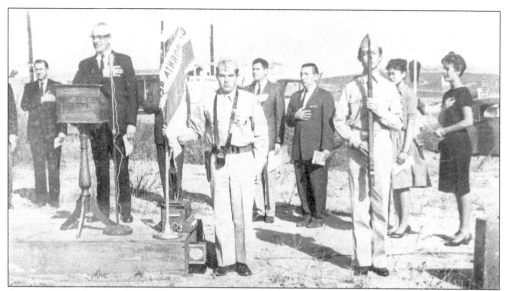

Originally, high school–aged students were sent to Escondido Union High School. In 1960, a dedication ceremony was held for the ground breaking of the new San Marcos High School. The first classes began in the fall of 1961 with 299 students and 18 faculty members. In some classrooms, the air conditioning would come on when attempting to turn on the heater due to crossed wires.

Former teacher Paul Barrios later commented that "everyone" wanted to go to San Marcos High School, since "everything was new." At the time, the school was near no shopping centers and was surrounded by open fields. By 1976, San Marcos High School and San Marcos Elementary School, taking back its former name, combined to form the current San Marcos Unified School District.

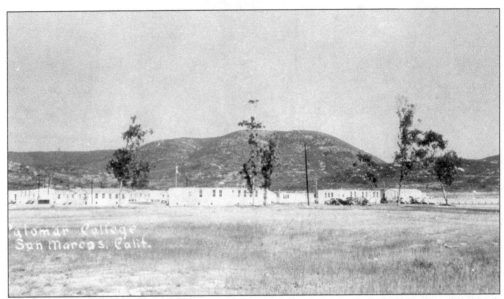

Palomar Community College was conceived as an idea in 1945 to improve the educational outlook for local war veterans. Classes were first held at Vista High School until land was acquired on a 133-acre cattle ranch owned by Brunson McKeen. In 1951, classes began in seven surplus military huts used as temporary classrooms in the middle of land said to be covered with brush and rattlesnakes.

By 1967, construction was finalized on the permanent Palomar College campus. The centerpieces would be the aluminum dome gymnasium and the large P on Mount Mitchell just behind the college. In 1950, student chairman Bill Tipton and a group of students sprinkled white lime over rocks that they had formed into a P to promote school spirit.

This photograph from 1983 shows Joe Willis enjoying a cigarette at the controls of the Palomar College Planetarium. With 1,500 students in 1963 and 9,500 by 1974, enrollment at the school continued to grow well into the 1980s. Recognition came for Palomar's achievements in various areas from chorus and theater to astronomy and technology.

Palomar College would also be recognized for its innovative American Indian Studies program, one of the first in the nation. In 1977, the campus held the Indian Heritage Festival featuring a powwow, demonstrations in Luiseño basket making, and a performance by folk singer and actor Floyd Red Crow Westerman, pictured here.

In 1979, San Diego State University opened a satellite campus for North County residents out of Vista Middle School. Three years later, the campus relocated to an office building on Los Vallecitos Boulevard in San Marcos. In 1985, Sen. William A. Craven launched Senate Bill 1060, which appropriated funds for a study into where to develop a four year university in North County, coinciding with the sale of the Prohoroff Poultry Farm to Stephen Bieri, a local developer. In 1988, Bieri (above, left) sold 304 acres of the property to CSU trustees for a permanent site for the newly accredited California State University San Marcos, which began holding classes at the former San Diego State satellite campus. The first faculty of CSUSM is pictured below around 1989.

Bill W. Stacy was chosen as the new university's first president and is seen here in 1989 looking towards the future site of California State University San Marcos, just prior to construction. The following year, building would begin on the university with a budget of $51.8 million.

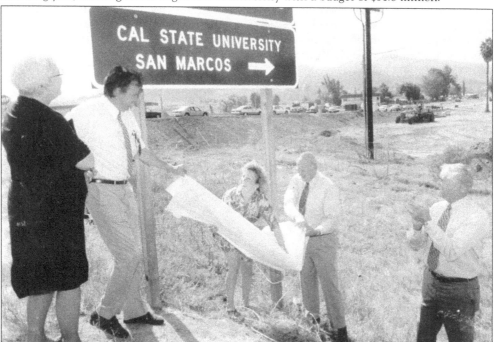

By 1992, with the completion of Craven Hall, Academic Hall, and Science Hall I, California State University San Marcos officially moved to its permanent home off Twin Oaks Valley Road with 1,700 students enrolled. A new sign was unveiled pointing the way toward the 20th campus to join the CSU system.

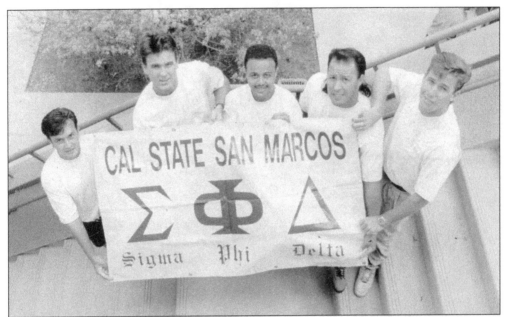

By its first semester, the campus featured a newspaper entitled *The Pioneer*, sports programs, and, pictured above, the first fraternity. From left to right are Ed Calvillo, David Drouault, Husane Riham, Billy Harrison, and Sean Martin. The campus gradually became a destination for students outside of San Diego County, and by 2003 University Village would open, allowing students to live on campus. When the school celebrated its 20th anniversary in 2010, student enrollment reached nearly 10,000, surrounded by new developments and bolstered by the extension of Twin Oaks Valley Road to San Elijo Hills. Below, past and progress combine under the shadow of Mount Whitney as a symbol of the city's incipient future.

Nine

A MASTER PLANNED
COMMUNITY

In 1940, the area southeast of Rancho Santa Fe Road was ideal for cattle grazing. George G. Clemson, who owned 1,200 of the 1,500 acres of land that would become Lake San Marcos, was a cattle rancher and dry farmer but was limited by his lack of a predictable water supply to pursue further enterprises.

Clemson's land featured a canyon created by San Marcos Creek, the natural waterway created from rainfall and a two percent slope from east to west in a flat area subject to flooding. In 1946, Clemson and his son-in-law John C. Wells began construction on a concrete dam in this canyon to impound the creek water and create a lake.

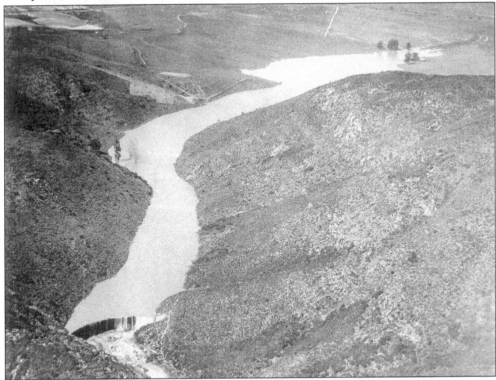

The dam was mainly self-funded, outside of some help from a government water conservation program. By 1951, the dam was completed and formed a 40-acre lake fed by over 29 square miles of watershed and an aqueduct that passed under the lake. With a new abundance of water, the family began farming tomatoes, onions, and various other crops.

Until 1961, local ranchers including the Neill family, pictured at "Lake Muddy," as the children had nicknamed it, leased portions of the land for running cattle. That year, Clemson decided to turn the land over for development. In July 1962, the Frazer brothers—three developers from Glendale—bought the property with plans to start a housing community.

Construction began on the community of Lake San Marcos even before escrow on the land transaction was closed. The lake itself was drained in 1963 and the shoreline reshaped and extended, doubling its area to 80 acres. This photograph shows the drained lake and the soon-to-be-underwater plumbing system being installed with buildings for the community shopping center under construction behind.

By late summer of 1963, the lake had been refilled and new houses and streets were near completion. The Citizens Development Corporation, made up of the Frazer brothers and other investors and contractors, developed an incredible promotion program including flying in Los Angeles columnists by amphibian aircraft, landing on the lake conspicuously spotted with sailboats, and sending them back to write promotional articles to advertise the community.

In the summer of 1964, Lake San Marcos officially opened with a grand celebration, featuring water skiers pulled by speeding motor boats, which was never allowed again. In its first year of habitation, the community won the national award for best planned lake community in the nation. The first homes bought in 1963 sold for $30,000, almost double the national average for that year.

Amenities within the new district of San Marcos, which to this day remains unincorporated, included the first built-in residential cable television in California, a 36-room motel, a shopping center complete with a neighborhood gift shop, and the Lakeside Community Recreation Building, pictured here during a late 1960s Fourth of July picnic.

Originally advertised as a community specifically designed for an "active retirement," Lake San Marcos events focused almost entirely on the senior community. With two 18-hole golf courses, golfing tournaments became one of the leading activities for residents. Here, Ernie Buckley (left) and Art Benton display their trophies after Benton defeated Buckley in 32 holes to win the 1977 San Marcos Men's Golf Tournament.

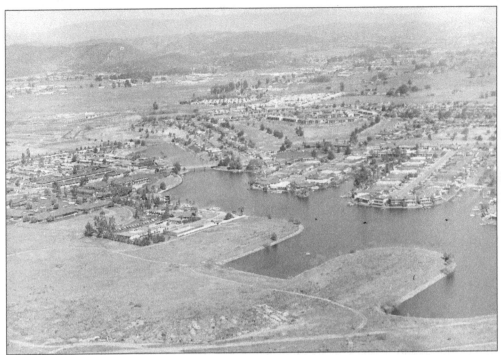

In the early 1970s, a dam was constructed to drain the western, lowest portion of the lake in order to construct a second aqueduct to pump water bought from the San Diego Water Authority to the lake in times of minimal rainfall, which was common. This photograph from 1975 shows the aqueduct near the left side of the lake, utilized as a bridge.

Pictured here in 1987, the Quail's Inn has been an elegant dining destination for local residents since first opening in 1964. While recently closed for renovations, the restaurant—along with the community—are evolving with age as more families have moved in and neighborhoods are no longer styled only for retirees.

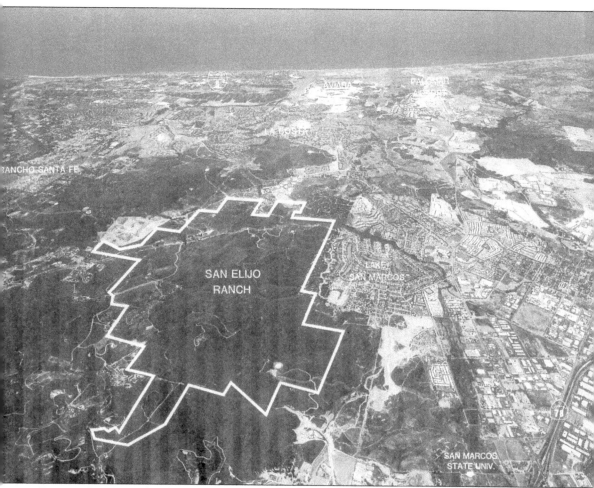

SAN ELIJO
RANCH

RANCHO SANTA FE

AVIARA

PALOMAR
AIRPORT

LA COSTA

LAKE
SAN MARCOS

SAN MARCOS
STATE UNIV.

Prior to the 1990s, development was never considered in the southwest region of San Marcos, now known as San Elijo Hills. The land, although within the San Marcos city boundaries, was associated as part of the steep, chaparral covered landscape on the ridgeline of the Cerro de las Posas Mountains. The area was given the name Elfin Forest by Francis Marion Fultz in the 1923 publication *The Elfin Forest of California*, where she surmised, if one were an elf, six inches tall, the ceanothus plants would look like the trunks of trees. Most activity in the area occurred at the San Marcos Landfill, which opened in 1979, and with local teenagers in search of the Lady in White rumored to haunt the surrounding hills. After the dump reached capacity in 1997, the city council approved an overall plan for San Elijo Ranch, a self-contained community development that would include 3,398 houses, two schools, a commercial center, and a 13-acre park.

Beginning in 2001, new homeowners moved into the renamed San Elijo Hills, which by 2004 housed over 4,000 residents and increased the city size by over five percent. That year, San Elijo Middle School was completed (with San Elijo Elementary opening in 2006), along with a town square featuring retail shops and a clock tower, pictured here.

Road building was an important aspect to the success of San Elijo Hills, as a portion of Questhaven Road was renamed San Elijo Road, widened to two one-way, multiple-lane roads and extended to connect with Twin Oaks Valley Road. Completed in 2009, Double Peak Drive was constructed to reach Double Peak Park, the view from which is pictured here looking down on the rest of San Marcos.

Ten

THE VALLEY OF DISCOVERIES

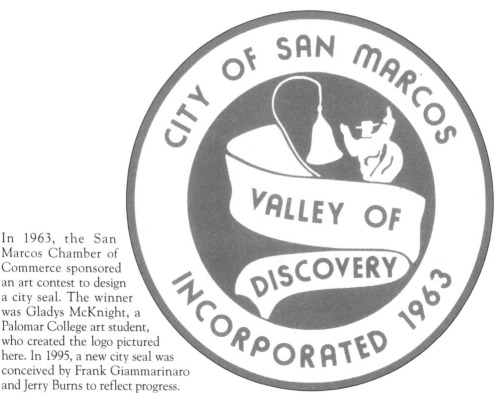

In 1963, the San Marcos Chamber of Commerce sponsored an art contest to design a city seal. The winner was Gladys McKnight, a Palomar College art student, who created the logo pictured here. In 1995, a new city seal was conceived by Frank Giammarinaro and Jerry Burns to reflect progress.

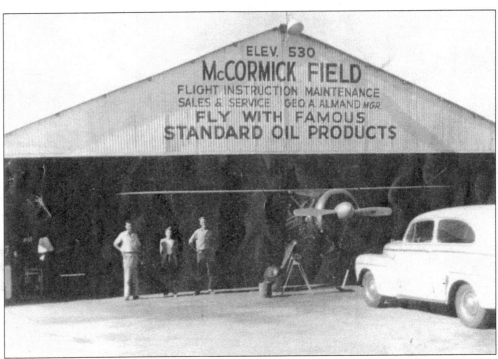

Opened in the late 1940s, McCormick Field was one of two airports in San Marcos just after World War II, located just north of San Marcos Boulevard between Bent Avenue and Via Vera Cruz. The airfield was managed by George Almand (right) and his wife, Jane Almand (center), until it was decommissioned in the 1960s.

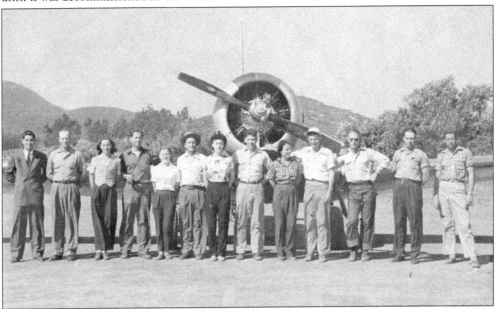

McCormick Field featured a flight school, taught by the Almands, called the Almand Air Academy Flyers, pictured here. The Ferguson family recalls parachutists from the airfield landing in their apricot trees. Peggy Ferguson remembers her mother Betty Ferguson, the first city clerk, storming out of the house with a broom. With a smile, Betty clarified, "I was only trying to help them."

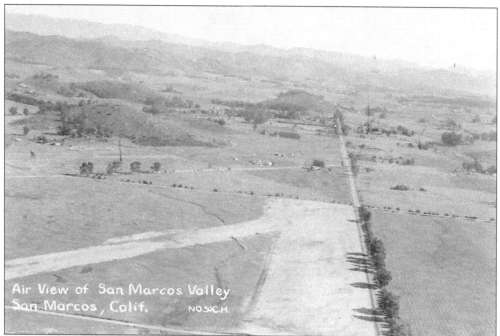

Air View of San Marcos Valley San Marcos, Calif. NO.50.C.H.

In 1960, Rosie Hamlin and friends drove from National City, arriving in San Marcos at an airplane hangar. Rosie and the Originals recorded Hamlin's song "Angel Baby" in the studio of Robert Kittinger, a retired ham radio operator who had set up two-track recording equipment in a corner of a hangar at the San Marcos Valley Airport, just north of Grand Avenue and San Marcos Boulevard, pictured above. The "studio" was scattered with airplane parts, and the saxophone solo was played by the bassist after the saxophonist had to stay home and mow the lawn. The B-side "Give Me Love" was an ad-libbed jam sung by friend Blueford Wade when the band realized they only had one song to record. "Angel Baby" went to No. 5 on the Billboard Hot 100 chart.

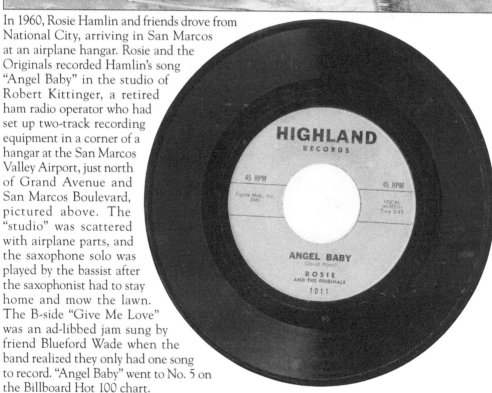

Robert Cummings, an Army Air Corps flight instructor and popular star of *The Bob Cummings Show*, owned a yellow and green Taylor Aerocar, described as a "roadable aircraft" in the 1960s. Pictured here, Cummings landed at McCormick Field to gas up before driving to a weekend stay at the Golden Door Spa. George Almand is pumping gas on the right.

The Golden Door Spa opened off Deer Springs Road in 1958 and moved just a short distance west in 1975 after the state took over the original site by eminent domain to construct Interstate 15. Founded by Deborah Szekely, the luxurious destination spa dedicated to the "balance of body, mind, and spirit," covers 377 acres. Director Anne Marie Bennstrom leads guests in a pre-hike warm-up class in this photograph. (Courtesy of Golden Door Spa.)

In 1975, Milan Andjelkovich sold his land on Knob Hill, valued at $100,000, for the construction of the Serbian Orthodox Church of St. Petka, pictured here. Andjelkovich sold the land for only $50,000, asking only that the church be named for his patron saint, Petka, a fourth century woman devoted to helping the sick and poor. In 1976, Crown Prince Alexander of Yugoslavia visited San Marcos to commemorate the church's completion.

While local lore often associates Questhaven Road with myths, the road in actuality is the site of the Questhaven Retreat, a 655-acre nature preserve and non-denominational Christian retreat center. Founded by pioneers of the isolated valley Flower and Lawrence Newhouse in 1940, the grounds, pictured here in the 1950s, originally consisted of only a stone house named Blue Gables, a windmill, and no electricity. (Courtesy of Questhaven Retreat.)

Bear and Cub Rock, the large rock formation and San Marcos landmark, sits atop the southern end of the Merriam Mountains separating San Marcos from Interstate 15. In the early 1900s, the spot was a common hike for local children. Pictured in 1924, members of the Borden, Fulton, and Gongora families enjoy the view.

Lee Fulton, pictured in his iconic Santa Claus costume, was considered San Marcos's "unofficial historian." After attending the Old Richland Schoolhouse as a child, Fulton for many years gave his "Little Bit O' History" presentation at monthly city council meetings. Recognized for his community involvement and spot-on Santa impersonation, Fulton was honored with a plaque outside city hall, naming him "the true Santa Claus of San Marcos."

Pictured prior to completion, San Marcos Brewery and Grill opened in 1993, rumored to be constructed with pieces of a debilitated warehouse and, possibly, parts of a San Pedro pier. The creation of former pharmacists Dave Nutley and Lee Gerich, the trailblazing brewery began producing four original beers, which are still favorites, and today remains as North County's first craft brewery.

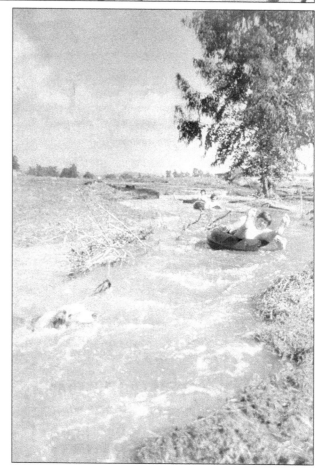

San Marcos Creek, pictured after heavy rain in 1978, was created during rainstorms as water draining toward the ocean collected near the city's lowest area to form a channel. The creek diverted to various locations, including fabled Three Falls, most of which have been dammed or rerouted. San Marcos is unique in having no specific downtown district, which the city plans to develop along the creek in forthcoming years.

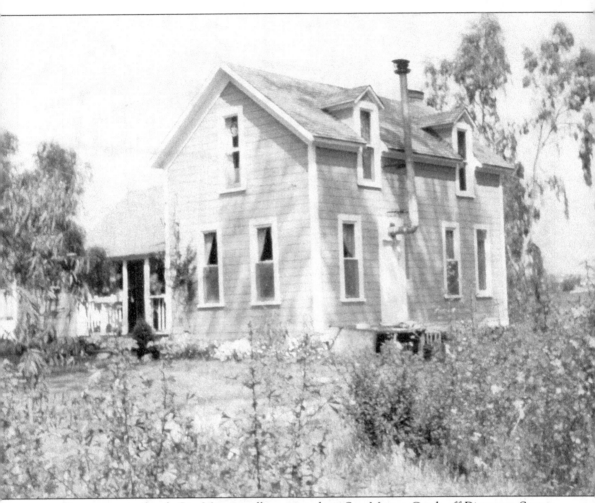

One remnant of early San Marcos still remains along San Marcos Creek off Discovery Street. The Meyer-Doran House, informally known as "the Pink House," pictured here before vacancy, is a Victorian ranch house built in 1889 by Wilhelm Meyer. Meyer's daughter Emma inherited the house in 1906 and allowed sharecropping on the surrounding land. The ranch was the sight of a quarrel over a piece of farm equipment between Gustave Eliason and William A. Doran, partners in the management of a threshing crew. Doran shot Eliason, who often drank wine at work, in the head after a struggle, possibly started after Eliason threatened to rescind the use of his equipment if Doran took away his wine. Doran was acquitted on grounds of self-defense, married Emma Meyer in 1912, and served two terms as a California assemblyman. He was deemed in his obituary a man who "draws warm, staunch friendships." Today the house remains vacant and may possibly be preserved as part of the proposed downtown district.

The San Marcos Historical Society was first established in 1967 with Flora Brown as first acting president. The historical society's first museum was housed inside a store Brown owned on Mission Road. In 1976, the historical society and museum moved into a restored farmhouse on San Marcos Boulevard that it called home for over 30 years. The Williams Barn, previously located next to the museum, was first relocated to Walnut Grove Park in 1992, followed by two historical homes built by pioneer Jacob Uhland—the Bidwell House in 2000 and the Cox House in 2002—which were placed in a gated area designated Heritage Park. In 2009, the Mary Young Conners Hall was moved to and restored in Heritage Park to serve as a historical museum. In addition, a welcome center was opened in 2010, which now houses the San Marcos Historical Society research library and conference room. Heritage Park is located at 1952 Sycamore Drive and is home to a large collection of photos and documents related to the history of San Marcos, California.

Visit us at
arcadiapublishing.com